baby photography now!

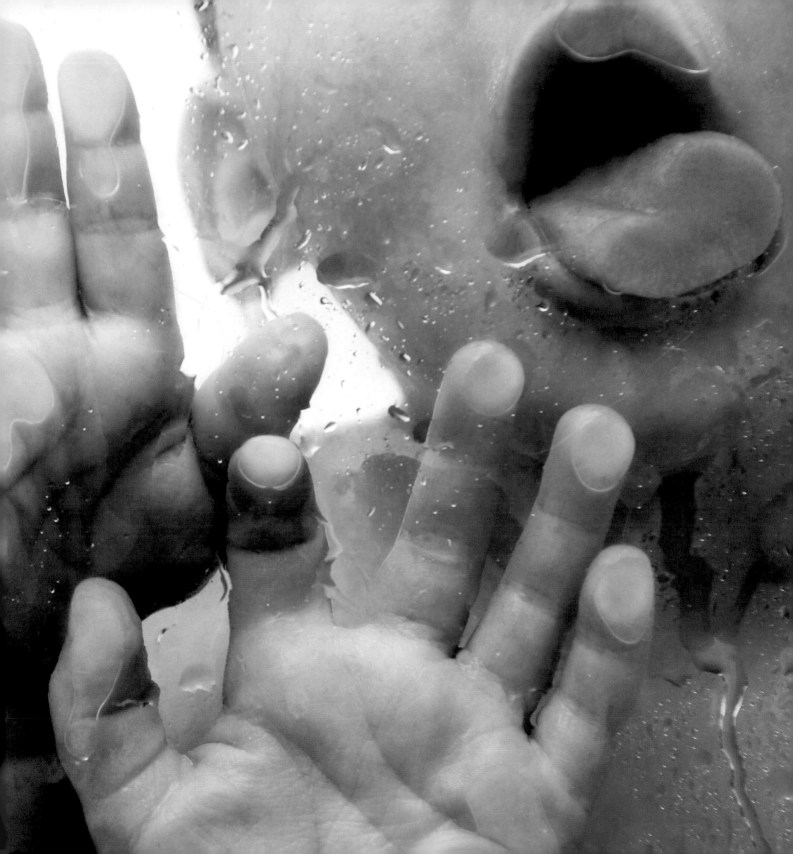

baby photography now!

shooting stylish portraits
of new arrivals

David Nightingale

LARK BOOKS

A Division of Sterling Publishing Co., Inc.

New York / London

Baby Photography NOW!
Shooting Stylish Portraits with Your Digital Camera

Library of Congress Cataloging-in-Publication Data

Nightingale, David Jonathan.
 Baby photography now! : shooting stylish portraits with your digital
camera / David Jonathan Nightingale. -- 1st ed.
 p. cm.
 Includes index.
 ISBN-13: 978-1-60059-211-9 (pb-with flaps : alk. paper)
 ISBN-10: 1-60059-211-2 (pb-with flaps : alk. paper)
 1. Photography of infants. 2. Portrait photography. I. Title.
 TR681.I6N54 2007
 778.9'25--dc22
 2007016842

10 9 8 7 6 5 4 3 2 1
First Edition

Published by Lark Books, A Division of
Sterling Publishing Co., Inc.
387 Park Avenue South, New York, N.Y. 10016

© The Ilex Press Limited 2008

This book was conceived, designed, and produced by:
ILEX, Cambridge, England

Distributed in Canada by Sterling Publishing,
c/o Canadian Manda Group, 165 Dufferin Street
Toronto, Ontario, Canada M6K 3H6

If you have questions or comments about this book, please contact:
Lark Books
67 Broadway
Asheville, NC 28801
(828) 253-0467

Manufactured in China

ISBN 13: 978-1-60059-211-9
ISBN 10: 1-650059-211-2

For more information on Baby Photography NOW! see:
http://www.web-linked.com/bnowus

For information about custom editions, special sales, premium and
corporate purchases, please contact Sterling Special Sales Department
at 800-805-5489 or specialsales@sterlingpub.com.

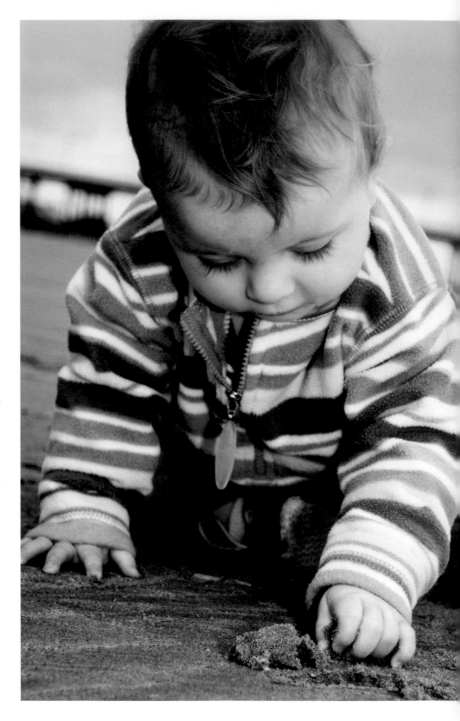

Contents

*I*ntroduction

When you first find out that you or someone you know is expecting a baby, it can seem a long time until the baby is due, and the point at which they will become a young child can seem almost unimaginably distant. But this journey isn't an especially long one, well under two years, and there will be many special moments, events, and emotions that you will want to record along the way. In this book I hope to show you how to make the most of this time, so that when you look back upon this period of your life, you will have a series of photographs to be proud of.

The book is divided into five chapters. In the first, "The Essentials," I discuss some of the equipment options available to you, from relatively inexpensive compacts that you can slip into a shirt pocket, through more expensive prosumer and professional models. We'll see what each of these generalizations means in practical terms, as well as looking at the range of lenses and accessories you might consider purchasing. It's important to have a broad understanding of these technical issues, but facts and specifications are only a starting point.

The emphasis in chapters two and three, on the other hand, is on the photographs you'll be taking—whether spontaneous or planned—and they cover a range of precious moments and poses, from pregnancy to your baby's first birthday and beyond.

With film-based cameras, unless you had access to a darkroom, pressing the shutter was the last stage in the photographic process. You would send your films to the lab, and hope that when they returned there were some you liked. With a digital camera, however, pressing the shutter is just one step along the way, and in chapter four, we look at some of the techniques you can use to enhance your digital images, including black-and-white conversion, soft-focus effects and how to create a montage of your favorite photographs.

There will be many special moments in the journey from pregnancy to child

Having produced your images, you then need to display them in some way, and the final chapter of the book discusses the many different ways in which you can present your photographs. This includes a summary of how to produce high-quality prints, how to make your images available on the web, and how to create stunning albums of your work.

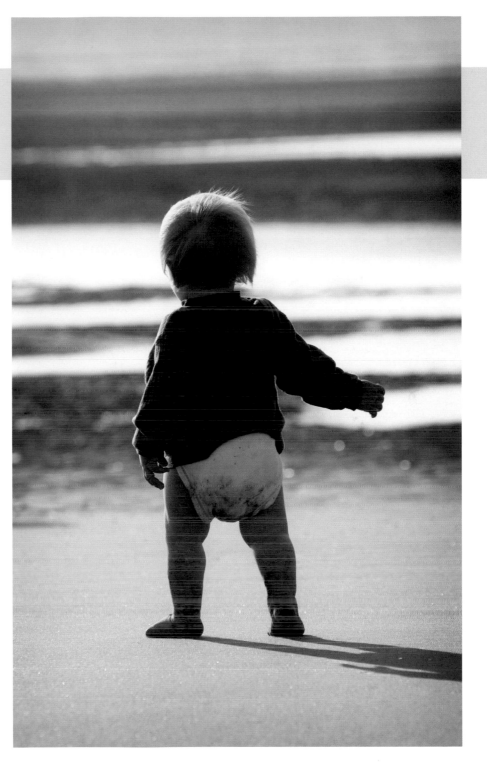

Right: Taken at 200 mm using a 70-200 mm zoom and an aperture of *f*5.6. At 200 mm, *f*5.6 produces quite a shallow depth of field, just deep enough to ensure that my son was in focus but the background would be pleasantly blurred.

Opposite: This was taken with a 17-40 mm zoom lens at an aperture of *f*4.0. I deliberately used a wide aperture to focus the viewer's attention on the text of the leaflet.

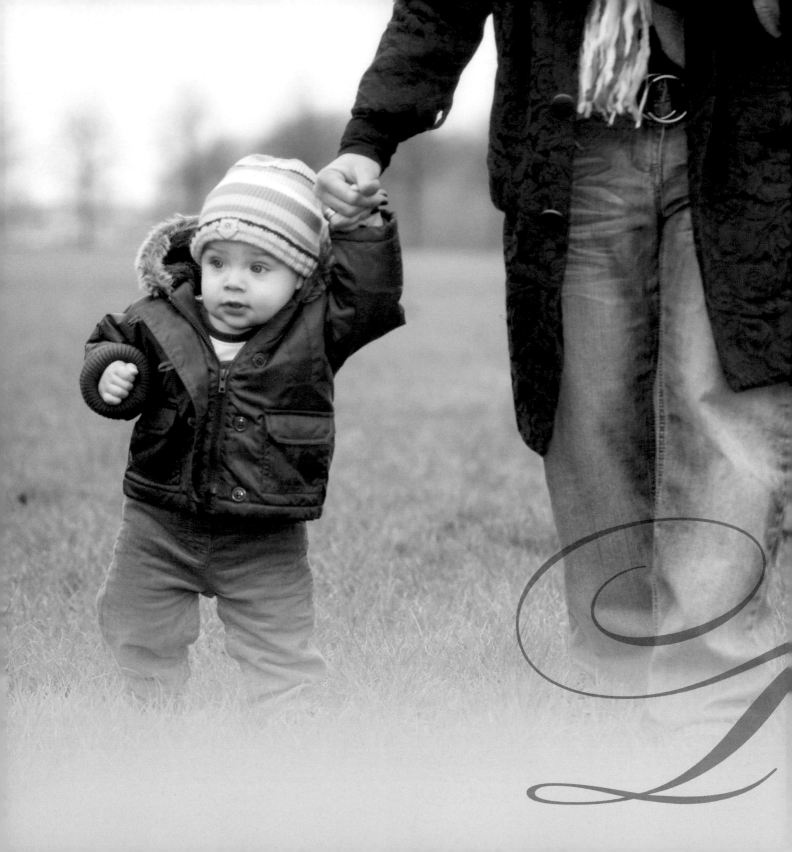

Equipment has always been part of the fun of photography, whether that comes from exploring every last feature of a shiny new digital camera, or rummaging through yard sales for a bargain prime lens. In this day and age, things are even better; not only do you get to choose between a variety of camera shapes and feature sets unimaginable in the past, but you can also pick out stylish computers and printers that bring a clean, full-color production process into your own home. This is where the magic is made.

the essentials

Cameras

In 1975, Steve Sasson, an engineer at Eastman Kodak, took the first digital image. The camera he used weighed eight pounds, was the size of a large toaster, and took 23 seconds to record a 0.01 megapixel (10,000 pixels), black-and-white image to cassette tape. Over the next few years, a variety of cameras were produced, but it was not until 1991 that the first truly digital camera was available for purchase: the Kodak DCS-100. Based on a Nikon F3 body, it had a 1.3 megapixel sensor, a 200 MB hard drive that could store 156 images, and retailed at $13,000. Since those early days, manufacturers have made huge progress. You can now buy a range of devices, from seven-megapixel compacts that will fit in your shirt pocket and only cost a few hundred dollars, to relatively inexpensive prosumer cameras and more expensive DSLRs, to very expensive medium-format digital backs with resolutions in excess of 40 megapixels.

At first glance, when considering which camera to buy to record your baby's progress, a digicam such as the Canon Digital Ixus 800 IS might seem like an ideal choice; it's a six-megapixel camera, which is a high enough resolution to enable you to produce quite large prints, despite the camera being just under four inches (10 cm) long with a fully retractable lens. It also packs a 4× optical zoom, giving plenty of flexibility when composing shots, has a built in flash for situations where light isn't ideal, and a price somewhat friendlier than prosumer models and DSLRs. There are, however, a few factors you should consider before making your choice.

FOCUSING

Almost every digital camera on the market has autofocus—the ability to automatically determine the correct point of focus when you partially depress the shutter, based on either a central focal point or the camera's evaluation of the scene. With compacts, and even prosumer cameras, there can often be a slight lag between focusing and taking the shot, somewhere around half a second. This might not sound like a lot, and if your subject is perfectly still it probably won't affect the shot greatly, but it is something to bear in mind, particularly as your child becomes mobile. All DSLRs, on the other hand, use separate circuitry to determine the correct point of focus, and the shutter lag with these cameras is negligible. There are two further benefits of choosing a DSLR over a compact or prosumer model with respect to focusing. The first is that with a DSLR you can focus manually, i.e. you can override the autofocus. This is often useful if you wish to focus on an element of a scene other than the one that the camera decides is the most appropriate. The second benefit is that DSLR's also allow you to use focus tracking. In normal single-shot mode

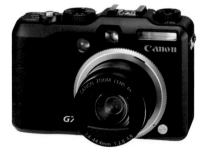

Canon PowerShot G7, a typical prosumer camera with high-end functions packed into a more portable form.

the camera locks the focus based solely on the camera-to-subject distance. With focus tracking, the camera also measures whether the subject is moving, and adjusts the focus accordingly.

METERING

Most digital cameras offer a variety of metering methods—ways of evaluating the light levels of a particular scene. Typical modes include evaluative or matrix metering, where the camera evaluates the entire scene and uses a number of built in algorithms to determine the correct exposure; center-weighted, where the exposure is based on the central area of the scene; and partial or spot, where the exposure is based on a small central area. The last two are particularly useful for portraits, especially if your subject is back-lit, as evaluative metering will often underexpose such scenes in an attempt to accurately record the whole scene.

HISTOGRAMS

Most digital cameras allow you to preview your images by viewing a histogram, which is a graphical representation of a particular exposure. This quickly becomes an invaluable at-a-glance method of measuring success, before perhaps switching to a different metering mode. Some models, typically DSLRs, also allow you to view the histogram as individual RGB channels. This presents you with three histograms, one each for the Red, Green, and Blue channels, or a colorful overlaid chart. This is useful in that while the image may appear correctly exposed when you view the preview, it can often be the case that one of the channels is overexposed.

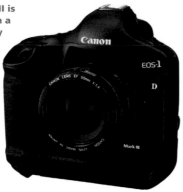

The Canon EOS-1D Mark III is a sophisticated DSLR with a full range of functionality and a price to match.

FLASH

Most digicams and prosumer cameras have a built-in flash unit, with higher-end cameras (especially DSLRs) tending to favor a popup flash. When light levels are low, these will allow you to get a shot. However, the results you will get will invariably be disappointing; the light is harsh, often unevenly distributed, and prone to causing redeye. Most prosumer cameras and all DSLRs also include a "hotshoe" for mounting a separate flash unit. These provide considerably better illumination and, unless you only intend to take photographs in well-lit surroundings, you should consider purchasing a camera with this facility.

WHITE BALANCE

Your brain corrects your vision so that white will always appear white, no matter the bias, or "color temperature," of the light falling on it. Cameras find this a little harder, as they don't have the intelligence to know what should be white or otherwise, but most are able to make a good approximation using their auto white balance modes. Failing that, there will be a number of options for you to choose from: daylight, cloudy, tungsten, and so on.

CAPTURE MODE AND FILE FORMATS

Most compacts only allow you to capture your images as JPEGs. Most prosumer models and all DSLRs also allow you to capture either TIFFs or RAW files. The benefit of TIFF is that it applies no algorithm to reduce the file size, so there is no chance of the picture losing quality.

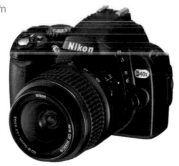

The Nikon D40x brings DSLR flexibility at a more wallet-friendly price point.

Better yet are RAW files, which typically include a vastly greater range of color shades than "8-bit" JPEGs (256 shades for each primary color), and also remember the camera's settings at the time the shutter was fired. Photographers generally feel that the extra data in 12-bit or 14-bit files makes it possible to adjust the exposure by up to two full stops in post-production.

APERTURE

The aperture is one of the mechanisms that determines the amount of light that reaches the sensor and, generally speaking, it's better to purchase a camera with a wide maximum aperture as this will allow you to shoot in low light. With DSLRs the aperture is determined by the lens, which can be changed, but with compact and prosumer models it's important to ensure that you buy a camera with a reasonably wide aperture at the outset, as this is something that cannot be changed later. It's also worth noting that the maximum aperture will often change as the focal length of a zoom lens changes. So, for example, while both the compact and prosumer models pictured have a maximum aperture of $f2.8$ at their wide angle setting, their maximum apertures when using the telephoto end of their zoom ranges are $f5.5$ and $f4.8$ respectively.

IMAGE RESOLUTION

Whenever you see a camera advertised, one of the main things that the manufacturer will stress is the number of megapixels it can capture. Typically this will range from five megapixels for a relatively low-cost compact, through the teens for serious DSLRs, to nearly 50 in specialist medium-format camera backs. One thing you should bear in mind is that the number of megapixels does not necessarily equate to image quality. For example, the sensor in a ten-megapixel DSLR is considerably larger than the one in a ten-megapixel prosumer model, and as such the quality of each pixel is higher as it can more accurately capture the color and luminosity of the scene.

CONCLUSION

Ultimately, your choice of camera will probably be determined by your budget, and the majority of compacts, with their relatively low cost and small size, will seem particularly attractive. Prosumer models are more flexible and are great if you want the flexibility to go for more artistic shots, safe in the knowledge there will always be a full auto mode. DSLRs are both more expensive and bulky by comparison, but do produce higher quality images and are considerably more flexible, especially in terms of their ability to accept interchangeable lenses, as we'll see on the next page.

Lenses

If you opted to buy a DSLR, the chances are you also bought the kit lens, typically an 18-55mm zoom, and for most situations you will probably have found this quite adequate. At 18mm the field of view is quite wide, while at 55mm the zoom is long enough to let you close in on an area of a scene that interests you. So why should you buy another lens? Or, if you're thinking of buying your first DSLR, why should you buy anything other than the kit lens?

There are two main reasons. First, the cost of a lens is proportional to its quality and the number of lenses a manufacturer can sell. Clearly, the major manufacturers can produce their kit lenses relatively cheaply as they can expect to sell them in high volume, but they often aren't especially good lenses, either in terms of their build quality or their optical performance. The second reason is that the kit lens is quite limited, in terms of both its focal range and maximum aperture (typically $f3.5-f5.6$), and as such isn't ideally suited to anything other than general photography. Certainly a wider aperture (smaller f number) would be useful in low-light situations.

Having said all that, how do you go about choosing a lens, especially since Canon and Nikon, the major DSLR manufacturers, both produce a huge range to accompany their cameras? In addition, companies such as Sigma, Tokina, and Tamron all produce a variety of third-party lenses that can be used with all the major makes of DSLR. In light of this, choosing the right lens can often be bewildering, especially when lenses that appear quite similar can vary so dramatically in price. For example, Canon currently produce three 50mm standard lenses: the cheapest, with a maximum aperture of $f1.8$, costs under $100, while the most expensive, with a maximum aperture of $f1.2$, costs well over $1000.

So what do you need to consider when buying a new lens?

FOCAL LENGTH MULTIPLIER
Because the sensors in most digital SLRs—other than a couple of exceptions we'll come to in a minute—are smaller than 35mm film, the focal length of the lenses you use appears to be greater than when used on a film-based camera. For all Nikon DSLRs the focal length multiplier is 1.5 (so a 50mm standard lens has an apparent focal length of 75mm). For the Digital Rebel series the multiplier is 1.6 (so a 50mm standard lens has the same field of view as an 80mm lens on a standard film-based SLR) while for the 1D MkII and MkIII it's 1.3. Some Canon models have full-frame sensors, in that they're the same size as 35mm film and don't alter the apparent focal length of a lens, but they're in a minority. While this may seem complicated, it is important insofar as the same lens will capture a different field of view depending on which camera it's attached to. For example, a good focal length for a portrait lens is 80mm, but with a 1.6 focal length multiplier this would become 128mm so you might want to consider purchasing a 50mm lens instead. Likewise, if you're looking for a good standard zoom lens for a Canon 30D, Canon's 17-40mm would be a good choice as the 1.6 multiplier effectively converts the lens to a 27.2-64mm lens.

FIXED FOCAL VERSUS ZOOM LENSES
Zoom lenses offer a range of focal lengths within one lens and are typically designated as wide-angle zooms (around 17–40mm), standard zooms (around 24–70mm), and telephoto zooms (typically in the range of 70–200mm). There are also a variety of lenses that cover a much wider range, such as Nikon's AFS DX VR 18–200mm, but these are less common, and generally more expensive. The benefits of using a zoom lens over a fixed focal length lens are that you can vary the field of view without having to move your camera, and can shoot a variety of different scenes without needing to change lenses. For example, the 24–70mm range is especially useful. At 24mm the lens will cover 74 degrees—useful for landscape photography—while at 70mm this narrows to 29 degrees, which is great for portraits.

Fixed focal length lenses, on the other hand, do have a number of advantages. Clearly, they aren't as flexible as zoom lenses, but they tend to have a higher optical quality as they're simpler to construct and are optimized for a single focal length. This tends to mean that a photograph taken with a fixed focal length lens will generally be sharper than one taken with a zoom. A second benefit of using a fixed focal length lens is that they tend to have wider apertures than a zoom that covers the same focal range, allowing you to shoot in lower light or with a shallower depth of field. "Prime lenses" are also considerably lighter than their zoom equivalentss.

Canon 50mm fixed lens

SUBJECT MATTER

The key factor in deciding which lens or set of lenses to purchase, is the use to which they will be put. For example, if you want to take a shot of your child learning to crawl, then a standard zoom lens will be much more useful than a fixed focal length lens. As your child crawls toward you, you can alter the zoom to keep them in the frame, rather than having to crawl backward to recompose the shot. A good choice here, if you have a camera with a focal length multiplier of around 1.5, would be something in the 17–40 mm $f4$ territory, or, budget allowing, a similar range of focal lengths with a $f2.8$ aperture. (Full-frame sensors should aim for the range 24–70 mm.) These lenses are also ideally suited for family outings, allowing you to alternate between a reasonably wide field of view and a moderate telephoto setting.

Telephoto zoom lenses are also useful, especially when you want to be less intrusive, for capturing slightly older children when they're playing without interrupting their games, for example. They allow you to be farther away from the action, yet you can zoom in on the details of their activities without needing to move or disturb their concentration.

Nikon AFS DX VR 18-200 mm f3.5-5.6

IMAGE STABILIZATION

A relatively recent innovation in lens technology is image stabilization, known variously as "IS," "VR" (Vibration Reduction), and "Super SteadyShot." This technology uses motion sensors to detect tiny vibrations as the camera is held, and then automatically move a lens element to compensate for the blurring that would otherwise occur. Nikon's most recent version of the technology can allow you to shoot by hand for up to four more f stops before resorting to a tripod. For portraits, the ideal focal length is somewhere around 80mm.

WIDE APERTURE

Unlike vibration reduction technology, a traditional wide aperture (low f number) will leave you with a reduced depth of field (the range from the lens that appears in focus). This is great for creating

Canon 16–35 mm wide-angle lens

artistic photographs, but remember that focus is especially critical when the range is reduced in this way. If your subject is facing the camera, try focusing on their eyes, as these are often the primary point of interest in a portrait.

17–40 mm lens

The quality of a lens is proportional to its cost

A lens extender doubles the zoom length of the lens

Computers and other hardware

COMPUTERS

Virtually every computer you can purchase today, whether Mac or Windows-based PC, desktop or laptop, will run Adobe Photoshop. To obtain the best performance, however, there are a few things you should bear in mind.

When you're deciding which computer to buy, the use to which the computer will be put should be the determining factor in choosing which one to purchase, rather than the precise specification. For example, if you're intending to spend several hours a day post-processing complex, multi-layered, 16-bit images, then it will make sense to go for a high-end desktop system. If, on the other hand, you will only be working on a few JPEGs, once or twice a week, then the time you will save by using a high-end machine will be negligible.

If you do decide you need the best performance, the first thing you need to consider is the processor speed as, invariably, the faster the processor, the quicker the computer will be in applying Photoshop filters, saving files, and so on. Of equal importance is the amount of RAM (Random Access Memory) you have installed. Photoshop, by default, will utilize the memory it has available to it (up to its limit of 3–4 GB).

If this isn't sufficiently large for the image you're working on then Photoshop will write a portion of its current data to your hard drive or scratch disk (if you have one configured), which is considerably slower than working in RAM. In this sense, the more RAM you have installed, the better, and I would suggest that you aim for a system with 2 GB or more.

Another factor you need to consider is the size and speed of your hard drive. A typical Photoshop file can be anything from 50 to several hundred megabytes in size. In other words, you could fill a 40 GB hard drive with as little as 200 Photoshop files, so it's a good idea to install a hard drive that's sufficiently large for your requirements. Also, if you're routinely working with large images, it's worth considering using 7200 RPM hard drives rather than the cheaper 5400 RPM or 4200 RPM drives as the disk read and write speeds are considerably greater.

BACKUP
One thing that is easy to overlook, especially since computers are generally quite reliable, is backing up your images. If your hard drive fails, or your computer is stolen, you can lose all your photographs, so it's essential that you keep at least one copy. There are two options that I'd recommend: using an external hard drive (either Firewire or USB), or backing up to optical media (CD, DVD, or Blu-Ray). Whichever solution you choose, do make sure that you back up your images on a regular basis. I once managed to accidentally delete several thousand images, which weren't backed up, so now I run a routine backup of my main hard drive on a daily basis.

MONITORS
When purchasing and using a monitor for graphics work there are two things to consider. The first, and most important, is to ensure that your monitor is properly calibrated. That means it will faithfully reproduce both the tonal range and the colors of your image (see page 114). The second issue relates to the resolution of your screen, and while it's perfectly possible to use any graphics package on a screen with a resolution of 1024 × 768 pixels, this is by no means ideal, not least because any palettes that you have open will obscure the image you're working on. As a minimum, I'd suggest a screen with a resolution of at least 1280 × 1024 pixels, but if you can afford a larger display it will make using Photoshop considerably easier.

GRAPHICS TABLETS
Though by no means essential, a graphics tablet will speed up your workflow when working in Photoshop, especially if you routinely do a lot of dodging and burning of an image or work with complex masks. They don't allow you to do anything that you couldn't do with a mouse or trackball, but they do enable you to do it more accurately and quickly, especially since they're pressure sensitive.

When choosing a computer, think carefully about how you intend to use it

FLASH UNITS: THE BASICS

The majority of entry-level and mid-range DSLRs include a built-in flash unit that will pop up when required. However, these are not especially powerful or flexible, and tend to produce quite poor results. In terms of the former, the power of a flash unit is expressed as a Guide Number, which represents an exposure constant based on the distance to an object times the f number. For example, the flash unit on the popular Canon Digital Rebel XTi (EOS-400D) has a guide number of 43 ft (13 m). That is the maximum distance the

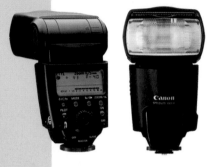

flash can reach when shooting at the virtually mythical $f1$. At a more usual $f4$ that falls to 11 ft (3.25 m). At $f8.0$ it drops to 5.3 ft (1.63 m), and so on. By comparison, Canon's top-of-the-range external flash unit, the 580EX, has a Guide Number of 138 ft (42 m).

A further drawback with built-in flash units is that they can produce quite harsh, unnatural looking results as they direct their light straight at the subject. Many external flash units, on the other hand, allow you to reposition the flash head so that you can bounce the flash off a wall, ceiling, or some other object. Images taken with bounced flash generally appear much softer than those taken with direct flash. Additionally, if you have no option other than to point the flash directly at your subject, the majority of external flash units can be fitted with a softening diffuser.

Built-in flash units tend to produce harsh, unnatural results

To illustrate these points I have included three images, all of which were flash-lit using the same Canon 580EX Speedlite. The first was taken with the flash pointing directly at the subject, in this case a china doll. As you can see, the lighting in this shot is quite harsh. The second was taken with a Stofen diffuser (available from www.stofen.com) placed over the flash head. This is slightly softer than the first image, but still looks much like a typical flash-lit image. The third image, on the other hand, was taken by bouncing the flash off the ceiling. As you can see, this looks considerably more natural than the other two shots. It's also worth noting

that the background is also illuminated in this photograph, whereas in the other two it was quite dark. This is because the light is bounced around the room before lighting the subject such that the surroundings are illuminated, too. This is especially useful for indoor portraits where you have no option other than to use a flash and is a technique I used for quite a large number of the photographs included in this book.

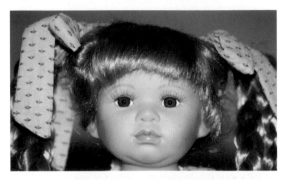

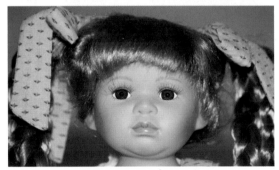

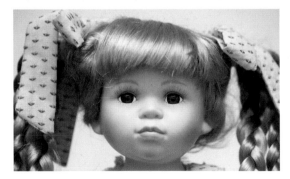

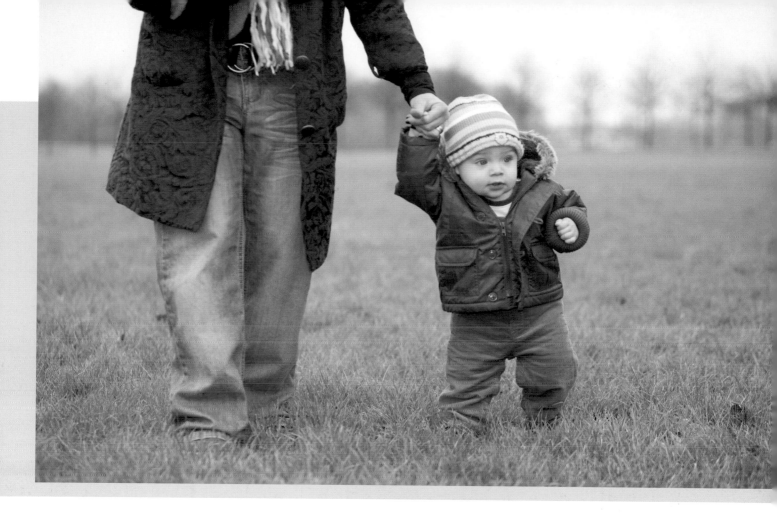

FILL FLASH

The three images of the doll were all produced in a relatively dark room, and used flash as the main source of illumination. It's also possible to use your flash unit to supplement naturally available light. The example above doesn't look flash-lit, but there are a few obvious signs. If you look closely, you will see two relatively bright points, one on each button of the young child's jacket. You might also notice that his mother's belt buckle seems very well illuminated, despite being hidden among the folds of her coat. However, neither of these points detract from the image, and had I not used fill flash, both subjects would have appeared quite dark in comparison to a flat, dull, but relatively bright, sky. In this sense, the fill flash has added light to an already well-illuminated scene, and in doing so it has filled out some of the shadows and created a more evenly illuminated final result.

FLASH EXPOSURE COMPENSATION

In the fill-flash example I also used flash exposure compensation to tone down the effects of the flash; in this instance by two thirds of a stop. When you use exposure compensation to alter the exposure of an image, you tell your camera to either under- or overexpose based on the reading from your camera's built-in meter. This is especially useful in circumstances where your camera's meter might be fooled, for example when your subject is backlit or unusually bright or dark. Flash exposure compensation works on much the same principle; you alter the flash output from the setting that the camera and flash unit determined would best to illuminate the image. When using fill flash, it's often a good idea to tone down the flash by one-third or two-thirds of a stop, as this produces much more natural and balanced-looking images.

The benefits of using an external flash unit are immense, both in terms of allowing you to produce natural-looking shots in poorly lit situations, and their ability to add precise amounts of light to an otherwise well-lit scene. If you only buy one additional item to accompany your camera and lens I would suggest that you buy a flash unit with an adjustable head. They are not especially cheap, but they will enable you to produce much better photographs when the naturally available light isn't ideal.

Off-camera lighting

FLASH UNITS

The previous couple of pages demonstrated a variety of ways of using your flash unit while attached to your camera: direct flash, direct flash with a diffuser, and bounced flash. But these aren't your only options. You can also remove your flash from your camera entirely and trigger it with a remote trigger, a device you place in the shoe mount of your camera in place of your flash unit. Or, alternatively, you can attach it to your camera with a remote cord, a coiled piece of wire around 3 ft (1 m) in length that transmits data between your flash and your camera. Both of these options give you a great deal of flexibility in how you light your subjects.

Perhaps the simplest, and most useful, reason for off-camera lighting is that you can sidelight your subjects. In the examples here, the flash was placed at 90 degrees to the doll and triggered remotely. As you can see, the strong, directional light has produced a much more interesting result than simply lighting the doll from the front or using bounce flash.

For the second, rather Gothic example, the flash was placed immediately below the doll.

Strong directional light can produce interesting results

While this isn't a technique that you're likely to use all that often when photographing your babies and children—not least because it's rarely flattering—it does demonstrate that the position of your main lighting source can dramatically affect the overall feel of your photographs. When used more subtly, by placing the flash farther away from your subject, it can produce good results (see page 72).

OTHER SOURCES OF LIGHTING

Other sources of lighting—candles, table lamps, flashlights, and so on—can also produce interesting

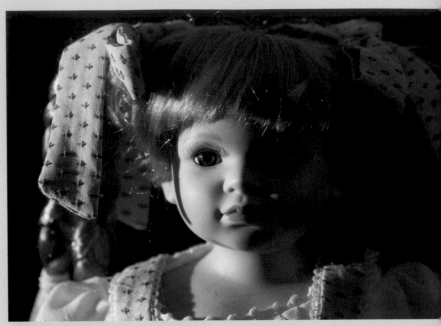

Sidelighting

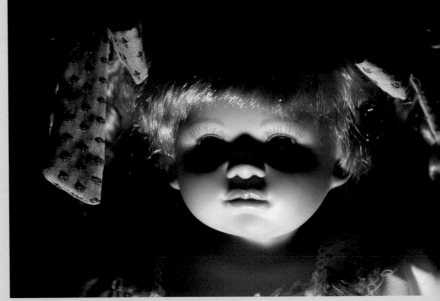

Lit from below

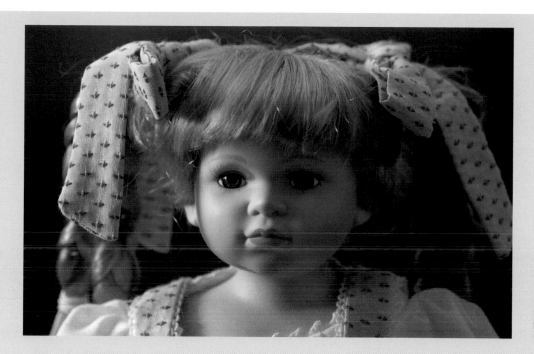

Lit using a desklamp positioned around 4 ft (1.2 m) to the doll's left.

results, which are often more subtle than those that can be achieved with flash. The light is a lot more diffuse, as in the desklamp example above, than when lit by a flash from the same position. The major problem, however, when using domestic light sources, is that they are extremely weak when compared to a flash. For example, the two flash-lit images in this sequence were both shot at 1/100th of a second, whereas this photograph needed an exposure of 2.6 seconds, a wholly impractical length of time when photographing babies and children, other than when they're asleep.

Studio lighting kits provide the ultimate control

STUDIO FLASH

Available light, a flash, or a combination of the two illuminated all the images in this book, but there is one more option that you might consider. Studio lighting kits, comprising a couple of powerful flash units and a combination of large diffusers and reflectors, can be purchased for roughly the same amount as a mid-range DSLR and provide the ultimate in lighting control. For example, the diffused

desklamp light could easily be replicated using a single studio flash and a large diffuser, but with the shutter speed of momentary flash. My personal preference, when photographing my own children, is to keep things as simple, unobtrusive, and natural as possible, but if you are interested in having more control over the ways in which you can illuminate your photographs, a set of studio lights may well be ideal.

Canon ST-E2 Remote Flash Trigger

Planning a shoot

Many of the photos you will treasure are the ones that are taken on the spur of the moment and capture the spontaneity of an event or occasion. However, there are plenty of occasions when you will appreciate having the time to plan a shoot, so in this section we will look at some of the things you need to bear in mind.

Before your baby arrives is a good time to try experimenting with planned shots. You might start by recording some of the preparations you have made for the baby's arrival, and can take your time over each photograph, varying the lighting, the camera angle, and so on. You could also shoot some "pregnancy portraits" during this period and, again, you can try out a number of different approaches until you find one that you are happy with.

Once your baby does arrive, you will find the pace of your life may alter quite considerably. But however chaotic the first few days or weeks seem, things will settle down, and babies are much easier to photograph before they are mobile, so make the most of this time. It's also worth bearing in mind that your baby will gradually assume some sort of routine during the first few weeks and months. This will largely be influenced by your parenting style, such as whether your baby feeds and sleeps by demand or to a schedule. Use this routine to plan your shots. For example, if your baby is fed every four hours, you will know exactly what time the next feed will be, and you can have all your equipment ready, having placed a chair in the right light, and set the stage for an intimate mother and child portrait.

My wife, however, breastfed all our children on demand, and they slept either in our bed at night or while worn in a sling during the day. In some senses, this made planning a shoot more difficult, but I soon realized that the children rarely went more than two or three hours between feeds. If we were at home, my wife preferred to sit in her rocking chair in the window. As we neared the time for a feed, I could start preparing a shot by arranging the angle of the chair and table lamp (or setting up other lighting) and could remove any other items, like burp cloths and magazines, from the immediate scene. When planning this sort of shot you should bear in mind the light at different times of the day, and account for this in your plans.

Sleeping babies can also make good subjects, particularly if they always sleep in the same place, as you will have time to arrange the bedding and toys you wish to include before they are laid down. But remember, you may have to pay more attention to lighting and exposure if the flash is likely to disturb them.

All these early photographs will stand you in good stead as your baby gets older, not just with your partner and family, but also because he or she will be so used to having the camera around that they will generally ignore it, allowing you to take much more relaxed photographs. I'm often asked how I capture my children looking "so natural," and I'm sure one of the reasons is that they simply don't notice, or aren't bothered by, the camera any more.

During your child's first year, there are many moments you will wish to record, including developmental milestones such as rolling, crawling, sitting, playing, standing, their first tooth, and their first steps, as well as family events such as birthdays, naming ceremonies, Christmas, and Thanksgiving. If you have the time, it's worth trying to set up some of these photographs before the event. This may sound contrived, but if you want a portrait to commemorate your daughter's first Christmas while wearing her new outfit, it's far better that it's taken before guests arrive rather than wait until she is exhausted by the excitement or has clumsily eaten a lot of chocolate. This is not a new concept; look in magazines and you will see that the celebrities are immaculately presented and groomed, photographed as they arrive at the beginning of an event rather than at the end.

It is also worth recording symbolic and sentimental items separately. These can be any items that are important to you—birth gifts and cards, first shoes, favorite outfits, toys, etc. Some of these items are covered in greater depth in other sections of the book, but from the photographer's point of view, they all give an advantage in that they will not get bored and crawl off before you are finished, allowing you plenty of time to plan and light your shot.

Your baby will develop a routine. You can use this to help you plan your shots

A good example would be the first birthday cake pictures (see page 38). Often, birthday cakes are lovingly and painstakingly made by a family member, and deserve to be recorded and included in an album, but an enthusiastic one year-old who is very excited to be the center of attention can destroy the entire cake in a matter of moments. A solution to this is to set up and take a photo of the cake at a quiet time earlier in the day. You will have time to check the shot, and can then relax and enjoy the spontaneity of the birthday meal while taking more casual family photographs.

Two of the key components to a good photograph are its content and the way this content is lit. With a planned shot, it's much easier to control both of these, at least to an extent, and the more effort you can put into planning your shots, the better they will be.

Precio

Bruno Forestier said that "Photography is Truth." Capturing the truth from key moments in your baby's life is the core of what this book, and especially this chapter, is about. From pregnancy, through those magical first moments, to your child's vital first milestones; these are the crucial photographs that you'll want to get right.

us moments

During pregnancy

By the time you read this book, my wife's latest pregnancy will be over, and our currently unborn daughter will probably be a few months old. For the moment though, we still have a few weeks to go, during which time I hope to photograph some of the many memorable moments that can occur during any pregnancy. While two of the large images here include my wife and our children, there is another aspect of pregnancy that is easy to overlook: the preparations that you make in advance of the birth.

Photography provides an opportunity to document the pregnancy for the unborn child

Photographs in this category could include shots of your newly decorated nursery, newborn clothes, toys that you have already bought, and much more besides. I chose to photograph our daughter's first pair of shoes against pure white (far right); this is a useful technique for isolating subjects from their surroundings. I could also have photographed them in the tissue paper in which they came when bought, or perhaps arranged them alongside other items that we've purchased in preparation for her birth.

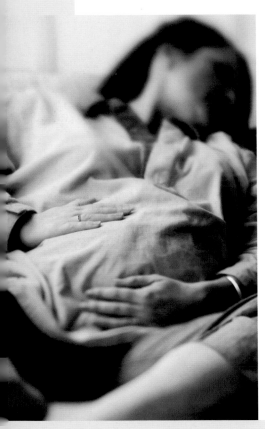

Left: Taken with a homemade tilt-shift lens, this image was then converted to black and white and toned using the Curves tool (as described on page 94).

A classic reclining shot (left) was taken with a tilt-shift lens when my wife was five months pregnant. One thing that tilt-shift lenses allow you to achieve is a very shallow depth of field, which I've used here to isolate her right hand resting on her bump. However, you could achieve a similar result with a very wide aperture on a normal lens. For example, $f1.4$ on a standard 50 mm lens would have produced a very similar result.

The main image here is as much about our other children as it is about my wife's pregnancy. It illustrates the fact that the moments you will remember from this period of your life need not be directly

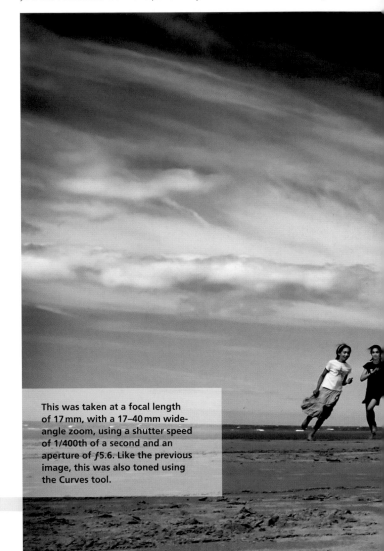

This was taken at a focal length of 17 mm, with a 17–40 mm wide-angle zoom, using a shutter speed of 1/400th of a second and an aperture of $f5.6$. Like the previous image, this was also toned using the Curves tool.

related to being pregnant. For example, my memory of this trip to the beach was that our children had a wonderful time just a few weeks before the birth of their baby brother.

One final thing to consider is that this is an opportunity to document the pregnancy for your unborn child. Clearly it will be some years before they can appreciate the images, but any photographs you take during this period will offer them a glimpse into your life before they arrived.

Right: This photograph was taken at ƒ5.6 with a 100 mm macro lens. I used fill-flash and a white, curved background as I wanted to focus exclusively on the shoes. The post-processing concentrated on using Curves to lift the highlighted details in the image, especially to make the background pure white.

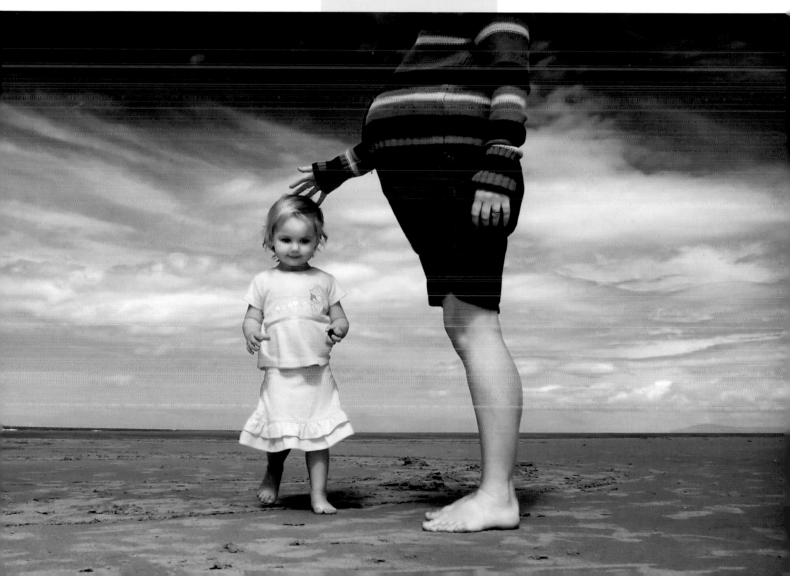

\mathcal{N}ewborn

When I look back through the many thousands of photographs I have of our children I realize that I don't have many of them as newborns, and none of them actually being born. This isn't because there's anything especially difficult about taking this sort of shot, but is probably more to do with being caught up in the moment. It isn't every day that you witness the birth of a new human being and, even with the best will in the world, it's easy to forget about recording those first few days. Even when you do remember, in the middle of all the chaos and excitement of your new arrival, it can be difficult to concentrate on creating a good photograph rather than just a visual record of the event.

That said, the two shots here featuring hands (below and opposite top) were both taken on our son's birthday, about nine hours after he was born. In the first, I've focused on both hands, for two main reasons. The first reason is because it's a shot that clearly illustrates his age. The second reason is more pragmatic; he was born nine days late so his skin, especially on his face, was very dry. The second shot is focused on just one hand, but in this photograph I've included my wife in the background. From the moment your children are born they enter into a variety of relationships, but the most significant of these is likely to be the

In the middle of the excitement it can be difficult to concentrate on taking photos

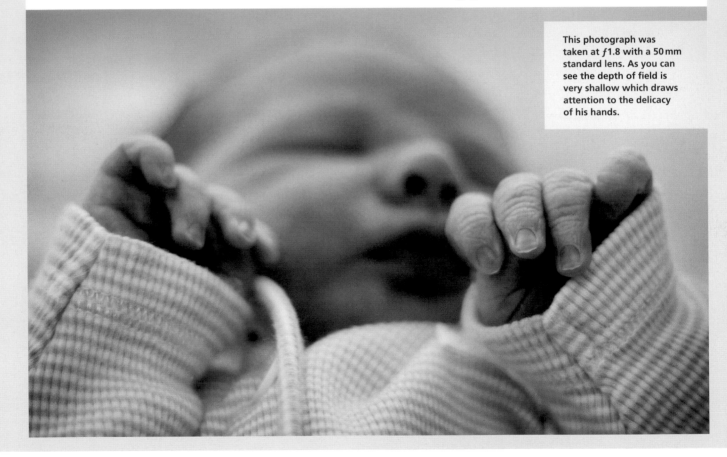

This photograph was taken at ƒ1.8 with a 50 mm standard lens. As you can see the depth of field is very shallow which draws attention to the delicacy of his hands.

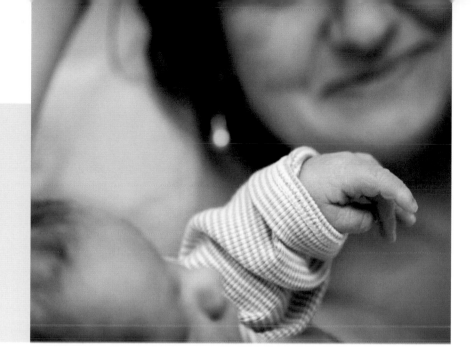

Left: Rather than startle your newborn by using flash, try using a higher ISO setting. This shot was taken at ISO 800, and while it's noticeably grainier than if I'd used ISO 100 and flash, this doesn't detract from the image in any way. One thing to bear in mind if you do use a higher ISO, is that the more expensive DSLRs can produce reasonably good results at an ISO setting as high as 1600, but digital compact cameras often produce quite noisy images at around ISO 400. The technology is continually improving, but it is worth doing some test shots to determine how well your own camera performs at different settings.

Below: This photograph was taken moments after the previous one and used exactly the same settings, but what this one demonstrates, more so than the other images in this set, is that if you want to capture these sorts of scenes then you need to be ready to take the shot the moment they arise. By the time you've taken your camera out of its bag and raised it to your eye, the moment that originally caught your attention has passed, so spend some time watching the scene through your viewfinder. That way you'll be ready to take the shot.

one with their mother. As such I was pleased with this photograph, in that it clearly captures one of those precious early moments.

The remaining two photographs in this set are of a one week-old baby interacting with her mother, and both demonstrate something quite significant about this stage in a child's life—how very quickly they change in those first few weeks. When newly born, at least for the first few days, babies will sleep for considerable periods of time and will rarely open their eyes. By the time the first week has passed, they will often be much more animated, so make sure you take plenty of photographs during these first few days.

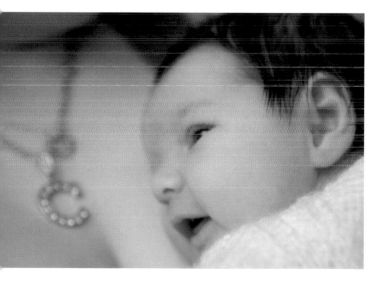

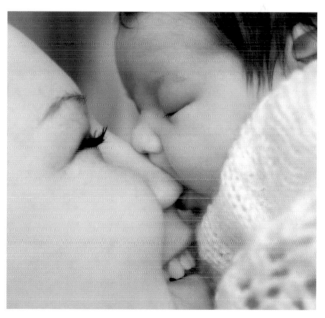

Bottom left: This photograph was taken at ƒ4.5 at 1/100th and used fill flash bounced from the ceiling. The major benefit of using the flash in this way is that it produces relatively natural-looking light, with none of the harsh shadows that direct flash can cause.

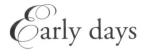

Early days

When your new baby first arrives, things can be a little hectic at times, but after the first week or so things will start to settle down and you can begin to establish some new routines: for you, your baby, and the rest of your family. Hopefully you'll also have a bit more time for photography, as this is a great time for taking photographs of your new baby—they're more alert than they were at first, any bruising from the birth will start to settle down and, if they have settled into a routine, you'll be able to plan the sort of shots you want to take and when you want to take them.

One photograph you'll definitely want to take at this stage is a portrait, both for yourself and other family members, particularly the ones who haven't yet met your new arrival. The first image in this set is a good example of this type of shot. It was taken when our son was six days old and we sent a low-resolution JPEG of the finished shot to friends and relatives around the world. You will also probably want to take a number of portraits of your new baby and other members of your immediate family. The second photograph in this group was taken of father and daughter when she was about one week old and the banner in the window clearly demonstrates that this is a shot taken early in this little girl's life.

The next two images in this sequence illustrate another aspect of these early days that you will probably want to record—the apparent fragility of your new child. Babies vary enormously at this stage—some being born at over ten pounds, others weighing much less—but they all seem incredibly delicate. One easy way to illustrate this is by photographing their hands and feet, both of which can seem very small. The final image in this set is on much the same theme, but in this case it's the overall size of this one-week-old baby that I've chosen to emphasize. By focusing on her pacifier you can clearly see that she's obviously quite small.

Take a portrait for those who haven't yet met the new arrival

Left: Photographically speaking, this was a relatively straightforward shot, taken at 1/50th of a second, at ƒ1.8 with a 50mm standard lens. It did require quite a lot of work in Photoshop afterwards, mostly because our six-day-old son still had very dry skin and was starting to develop milk spots. I spent quite a bit of time using the Clone Stamp tool and healing brush to smooth out the irregularities and blemishes.

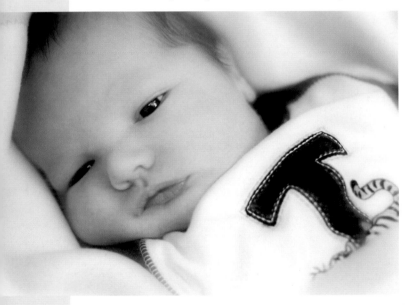

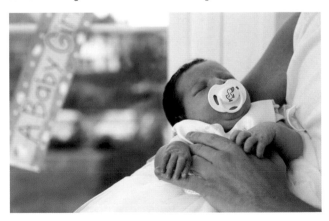

Right: This was taken with a 24–70mm zoom lens, at ƒ4.0—an aperture sufficient to ensure that the baby and her father were mostly in focus, but wide enough to throw the background out of focus. I used fill flash with the camera set to manual mode, and metered for the scene outside the window. Had I metered for the inside of the room, much of the outdoor scene would have been blown out in the final image, and as I wanted to include the banner in the shot it was important to produce a balanced shot.

Top left: Both these images and were taken at 70 mm (with a 24–70mm zoom) at ƒ4.0, and both used fill flash.

Top right: While the previous image clearly illustrated the size of this young baby's feet, this one also captures their delicacy.

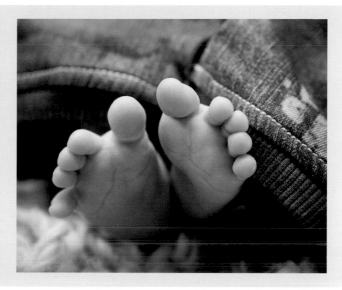

Right: By selectively desaturating the majority of this image using a masked adjustment layer, the viewer's attention is drawn to the pacifier and its size in relation to this young baby girl.

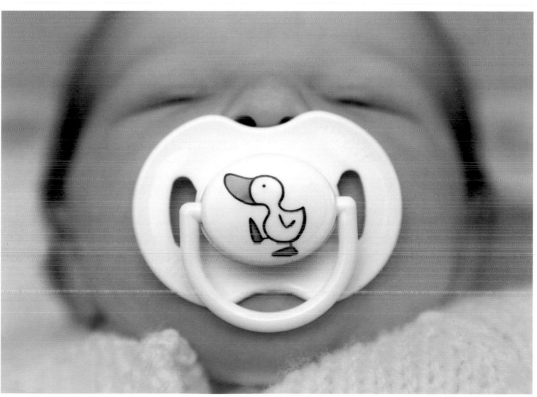

As I write this, we're expecting another daughter, which will bring the total number of children in our house to six. When they're not conspiring to turn our hair prematurely gray, they're a delight, especially when they're playing with one another. One of the things I'm especially looking forward to when our latest arrives is photographing her with her brother and sisters; from those early days when they will sit and hold her with pride, at least for a few minutes, to later on when she starts to develop her own relationships with them.

In the shot below, our son was around ten days old and had fallen asleep on his sister's shoulder. While it isn't a particularly clear shot of him, it does illustrate both the relaxed attitude of our daughter to her new little brother, and the fact that he's clearly comfortable in her company. The color image was taken a couple of months later, and this time it's our son and youngest daughter. When she was younger she tended to hug him a little too tightly, but from what I can remember he was perfectly happy on this occasion.

One thing that is worth noting about this shot is that it isn't even vaguely sharp. Often I'll soften my portraits of children in Photoshop, but on this occasion it was badly focused from the outset. That said, it doesn't detract from the mood or effectiveness of this shot and is something you can bear in mind when previewing your portraits of your children. Clarity and sharpness aren't essential for this type of image.

Though I used fill flash for this shot, bounced from the ceiling, the major source of light is from a north-facing window to the right. The benefit of window light, as opposed to flash, is that you end up with a much more natural-looking image, but it's also worth including a bit of fill flash to soften some of the shadows, especially for "gentle" portraits such as this.

Young children, especially babies, can't really be posed, at least not for more than a couple of seconds at a time. With this in mind I will often sit on the other side of a room with a zoom lens and just watch them through the viewfinder. In this Image, for example, my daughter was watching TV while hugging her brother, and wasn't paying any attention to me. The benefit of this approach is that you end up with images that tend to look much more natural, as you're not distracting your subject with your presence.

The image at top right was taken when our son was around four months old, as he played with two of his sisters on his play mat. What I especially like about this one is that it clearly shows how close they are to one another; even my daughter, who is looking directly at the camera, is snuggled up to him as he concentrates on his other sister.

Young children, especially babies, can't really be posed

The final image in this sequence is a little more abstract and shows an 11-week-old baby with his 14-year-old sister. While it isn't as emotive as the other three images here, it does capture one element of their relationship.

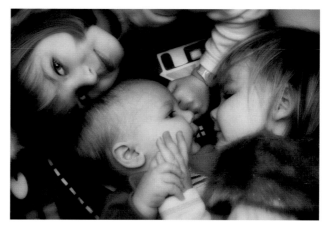

Above: This image was softened in Photoshop by the addition of a Gaussian blurred version of the original image as a new layer with the blend mode set to Soft Light.

Below: Even though this was shot at a reasonably wide aperture, there were still a number of distracting items at the top and bottom of the frame. Those at the top of the frame were removed by blurring that area of the image, and those at the bottom were painted over using a soft brush set to black. The result is an image with much greater impact as there are no competing elements to take your attention away from their hands.

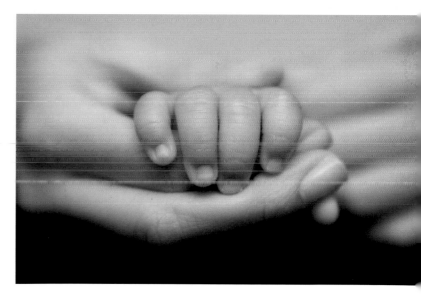

\mathscr{A} few months on

Young babies develop and change at an incredible pace. By the time they are several months old they are considerably more capable than when first born, both physically and cognitively, and this is reflected in the photographs I've included in this set. The large photograph below, for example, was taken a day after this young girl had "discovered" her thumb, and this captures something quite significant about babies of this age: while very young babies are poorly coordinated, as they develop they become much more controlled, both in terms of their own actions and in manipulating the objects around them.

The other two face shots both demonstrate these points, too. In the second, for example, while this young boy is still a few weeks away from being able to crawl, he has mastered the ability to roll from his back to his front. The third shot, of the same baby, also captures something quite typical of babies of this age—that they explore their worlds with their mouths, chewing anything that comes to hand.

The final shot here, of a five-month-old baby girl's shoe, focuses on a different aspect of babies in this age group, and parents of young children will immediately be able to recognize that this is either an extremely new shoe, or one that belongs to a child that isn't yet mobile.

What all the shots in this sequence share is that they capture some of the unique aspects of babies of this age.

Young babies develop at an incredible pace. Try to reflect this in your photographs

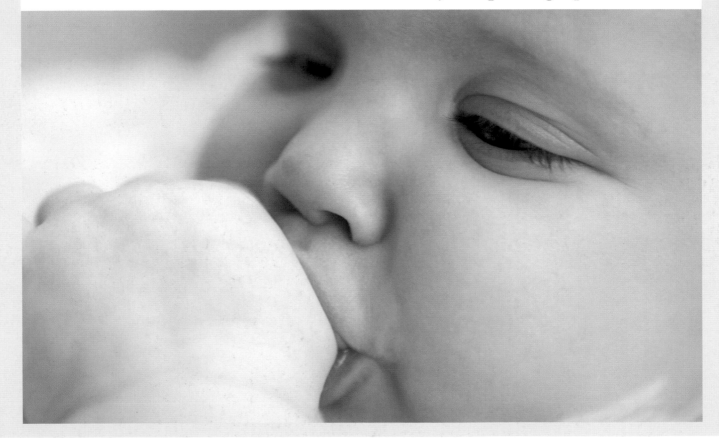

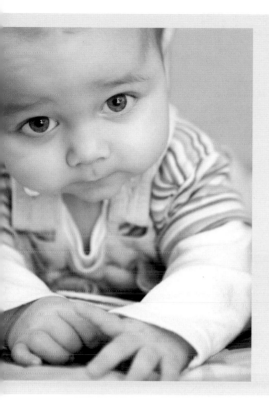

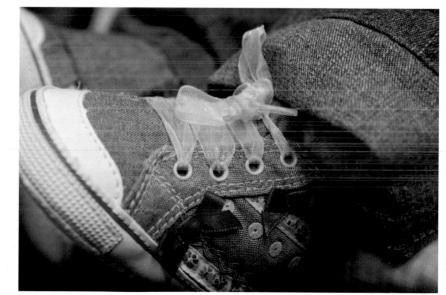

Above: This was taken moments after the previous image and used the same settings.

Below: This was taken with a 24–70 mm zoom, at 70 mm, but unlike the other images here I used ƒ6.4 to ensure that most of the shoe in the foreground was in focus.

Above: This was also taken with a 24–70 mm zoom, at 70 mm. This time I switched to manual (with a shutter speed of 1/60th of a second and an aperture of ƒ3.5) and used flash, bounced from the wall behind me, as the main source of illumination. The important thing to remember when using bounced flash is that you should aim to light your subject as evenly as possible. For example, had I bounced the flash from the ceiling when I took this shot, a good proportion of the image would have been in shadow.

Right: This was taken with a 24–70 mm zoom, at 70 mm, with a shutter speed of 1/30th of a second and an aperture of ƒ3.2. I used the available light from a north-facing window to her right, and as you can see this provides a very soft and gentle light.

leeping

Though a newborn baby can spend up to 18 hours a day asleep, and even children as old as a year will spend an average of 12 hours asleep, either at night or while napping during the day, it can often feel as though you have little or no time to yourself. So when they do go off to sleep you will probably be tempted to spend time doing all the stuff you didn't manage to get done while they were awake, or maybe you'll just spend some time relaxing, safe in the knowledge that they're out of harm's way for a while.

But you should resist both these temptations, because this is an ideal opportunity to take photographs, not least because it's much easier to photograph a sleeping child than one that's awake, and you can virtually guarantee that they'll look cute—something that can't always be said of small children when they're awake. The

image of two of my daughters sharing a bed is a good example. The youngest was just over one, her sister 17 months older, and they both look angelic.

You can virtually guarantee a sleeping child will look cute

If you're lucky, you'll have a child that will go to sleep where they're supposed to, either in their cot if they're small, or in their bed if they're a bit older, and both locations are ideal for a photograph, but children have a habit of falling asleep in quite unusual places. This can be a bit of a challenge, but it also presents you with a number of creative opportunities. The photograph of

Although this was shot at ISO 800 I also used fill flash, bounced from the ceiling, to add a bit more light to the scene. The diffuse effect was achieved by adding a Gaussian blurred version of the main image as another layer, with the blend mode set to Overlay.

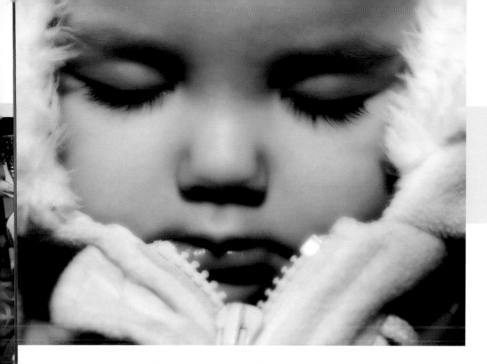

Left: As with the first shot in this sequence, this one was softened by the addition of a Gaussian blurred copy of the original image, overlaid on the original (again, with the blend mode set to Overlay). Some additional work was also done on this one, particularly in terms of further blurring the front of her coat and the zipper.

Below: The post-production for this image was relatively straightforward and involved little more than desaturating the image in Photoshop and lightening the midtones and highlights.

my daughter wearing her coat and hood is a good example. We'd just been out for a walk and she fell asleep in her buggy. Before she woke up I managed to take this shot by bouncing the flash of our hall ceiling. Likewise, the rather distorted image of her asleep on her front was another impromptu sleep, this time on a blanket on the lounge floor. It was taken through a crystal ball, hence the curvature at the top of the image, and it demonstrates an important point—when your children are asleep you have plenty of time to set up a shot and experiment with different angles and techniques, something's that not often possible when they're awake.

The final shot in this set, as you can see, was taken on the beach and, rather than take the obvious shot looking down from above, I decided to get down to her level and focus on her shoes. You can tell she's asleep from her posture—no child is ever this relaxed when they're awake—and the low vantage point allowed me to include more of the beach and the sky, placing her in context rather than just showing her and the sand around her. The main thing with this type of shot is that you should take your time because you'll get a much better shot if you do, and when children are asleep is one of the few times, if not the only time, you'll have the luxury of being able to spend quite some time thinking before you take the shot.

Bottom right: This was shot at *f*2.0 with a Canon PowerShot G5, and as you can see, despite the relatively wide aperture, the depth of field is quite large. Had I shot this image with a DSLR I would have had much more control over the depth of field and would probably have chosen to make it significantly shallower.

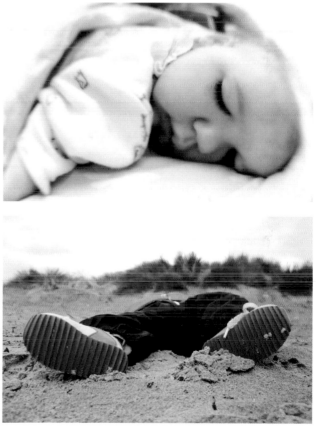

Children's lives are a sequence of milestones, and one that seems particularly significant is when they take their first steps. This, more than any other, marks their transition from being a baby to a young child. Developing a photographic record of this stage of their development isn't easy, however. It's easy to take photographs of their first steps—assuming you have a camera to hand when they take them—but it's more difficult to show that these are first steps rather than just shots of your child toddling around of their own accord.

One option is to arrange a pair of images shot a few moments apart. This not only captures one of the early stages that children will go through on their journey toward walking unaided—supporting themselves against things—but emphasizes experimentation. At first they may move along the length of a single item of furniture, but as they become more adventurous they will use chairs, tables, and anything else they can use as a prop, like walking stepping stones, lurching rather precariously from one to the other. One thing to bear in mind with this sort of shot is the lighting, especially if you are indoors, not least because their feet are often in shadow. One option is to use direct flash, either from a built-in flash unit or one attached to your camera, but the light will be quite harsh unless you use a diffuser. I use a Stofen diffuser (http://www.stofen.com) on my Canon 580EX Speedlite and this does a very good job of softening the light, but an alternative is to use bounced flash from a nearby wall to throw light back onto your subject. Either solution works well.

The remaining three shots, opposite, all capture different stages of a baby's journey toward walking unaided. The main image captures that very early stage where being upright seems more important than actually walking. After months of lying down, or maybe being propped up surrounded by cushions, most young children seem delighted with a more elevated view of the world.

The second of these three was one of a long sequence as this 11-month-old boy and his mother walked through the park. He hadn't been walking long, and couldn't get very far on his own, and I chose this shot above the others as it emphasizes his dependency on his mother; if she wasn't holding his hand, his center of gravity would almost certainly get the better of him and he'd end up sitting or lying in the grass.

Little feet are often in shadow. Use a flash with a diffuser to soften the light

Finally, the shot taken over water captures more independence. Here, at 13 months, the handholding is more for convenience than necessity, but what I especially like about this shot is his fascination with his foot. As I recall he made very slow progress up the beach, not because he had any trouble walking, but because the novelty of wet sand on his feet seemed infinitely fascinating.

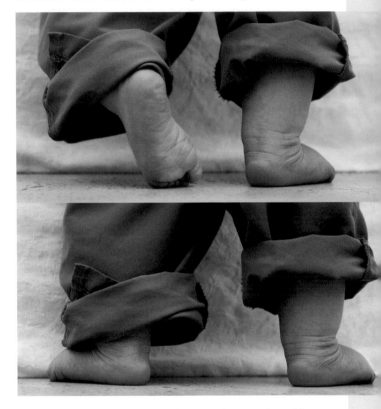

Above: This was shot at 1/100th second at *f*4.0 using a 70–200mm zoom. Both originals were cropped to a 2×1 aspect ratio in Photoshop.

Opposite bottom: This was taken with a 70–200mm zoom and then converted to black and white in Photoshop using the Black and White tool. The benefit of using this tool, rather than Hue/Saturation or the Desaturate command, is that you have much more control over the tonal range of the final image, through being able to set the balance of the Red, Green, and Blue channels and their relative contribution to the final grayscale image.

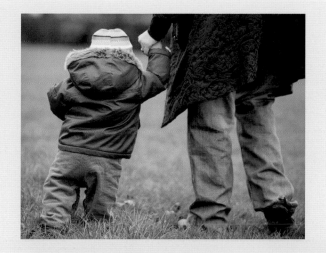

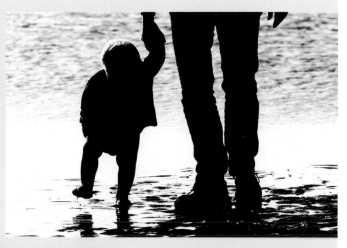

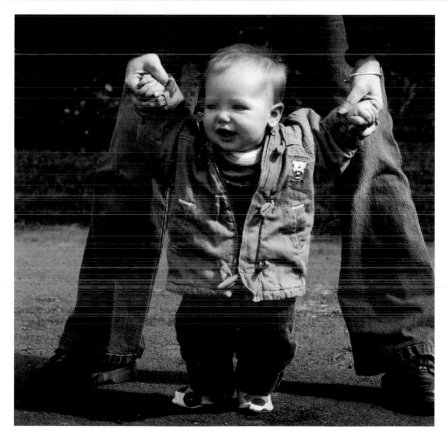

Top left: This was shot at ƒ2.8 with a 70–200 mm zoom, and as you can see, the depth of field is relatively shallow, isolating the mother and child from the background. The post-processing was relatively straightforward, and involved little more than boosting the saturation. A quick tip for shots such as these: if you want to make the grass appear more vibrant and colorful, try using Hue/Saturation to increase the saturation for the Yellows. Contrary to what you might expect, grass is much closer to yellow than green, at least as far as Photoshop is concerned, and increasing the saturation for the Greens won't make much of an impact.

Top right: Like the other three shots here, this one was shot with a 70–200 mm zoom, though this time the aperture was set to ƒ5.6, hence the greater depth of field. In terms of the post-processing, the major change to this image was a fairly dramatic increase in contrast, achieved using the Curves tool. The reason for this was that although there was some detail in my wife and son's clothing, both appeared relatively dark and the little detail there was in these areas was distracting. As a silhouette, the image is a lot more effective in drawing your attention to the main areas of interest.

Favorite toys

Toys serve a multitude of purposes. They can be instructional, they can entertain, they can provide comfort, and most children will have some they prefer over others. Photographing the toys themselves, as in the first photograph in this set, is relatively straightforward and is a topic we return to later in the book when I show you how to construct a montage from images of this sort (see pages 102 and 103).

Photographing children playing with their toys, on the other hand, can be a bit more problematic, not least because your presence can distract them. One way round this is to make sure that you're not in their line of sight. For example, the photograph below-right was taken from behind this young boy's head. He knew I was there, but because I wasn't immediately visible he concentrated on his toy rather than me.

To avoid distracting a child from his toys, make sure you move out of his line of sight

The opposite angle is used in the shot at top-right, as this five-month-old baby girl played with her pink doll. In this instance her attention switched between her toy and me, but by taking a series

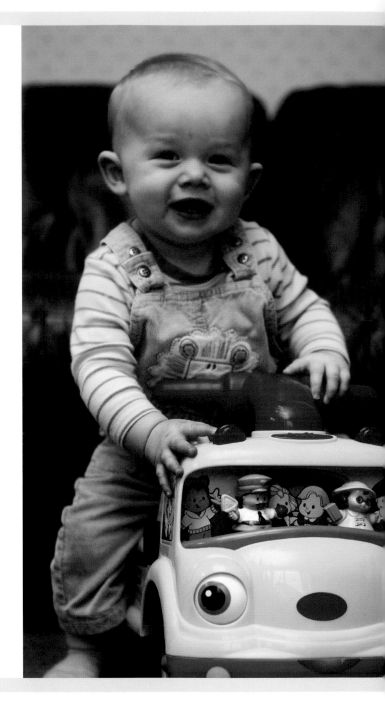

This was taken at 42 mm with a 24–70 mm zoom at ƒ4.0 and a shutter speed of 1/100th of a second. I used fill flash, bounced from the ceiling of the room, to provide a more even and balanced light.

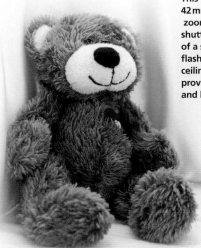

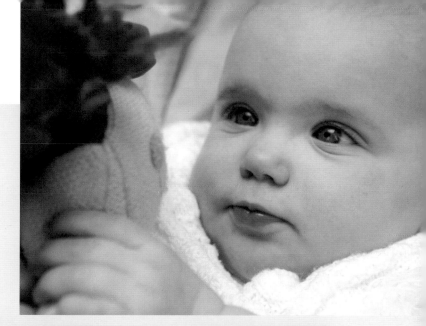

of shots I was able to get one where she was giving her doll her full attention.

The yellow car shot, on the other hand, takes yet another approach. This is much more of a "look at me" type of shot, so here, the fact that he's looking at the camera is much more appropriate.

One thing you might want to bear in mind, particularly if you're documenting your baby's first toys, is that it's often better to photograph them when they're fairly new, as by the time a toy becomes a firm favorite it's likely to have been chewed, dribbled on, and abused to the point where it won't make an especially attractive photograph.

Top right: Here I shot with my 24–70 zoom, but this time I used an aperture of f5.6 as I was much closer to the action and wanted to ensure that the depth of field was great enough to capture her expression. On reflection, I think an even smaller aperture, between f8.0 and f11.0, would probably have been better as this would have brought her eyes into focus, too.

Bottom right: This was taken at 70mm with the same 24-70mm lens as the shot above, but using fill flash. I used an aperture of f4.0 as I didn't want the entire image to be sharp. The main focus is on the toy's face. This draws the viewer's attention into the center of the image.

Opposite page: Unlike the other three images, this one was shot with the aperture wide open at f2.8, as I wanted to focus the viewer's attention on the toy drivers rather than the real one. I also wanted to ensure that the background was sufficiently out of focus so that it didn't distract from either the cab or the baby.

As adults, a bath or shower is either functional—you want to get clean—or it's relaxing, but for children it's also fun. They can splash around in the water, play with the bubbles and their bath toys, and be warm and content without needing to be bundled up in clothes or diapers. The first image I've included is a good example of this, and if left to his own devices, our son would probably spend several hours just playing with his duck. Another image I've included that continues the "fun" theme is opposite, showing my son licking the bubbles from his lips.

One thing that is worth bearing in mind when shooting photographs in this setting is that it's much better to use bounced flash rather than direct flash. With direct flash you will end up with numerous bright spots in your image, as children are considerably more reflective when wet. If you bounce the flash from the ceiling or a wall, the light will be more diffuse and your photographs will be much better lit.

The main photograph opposite involves a change of location, from the bath to the shower, and shows our youngest two daughters playing together. An interesting way to round off the session is with a drying-off shot, like the one at top right. This demonstrates the change of pace that can occur when bathtime is over. Worn out from playing with his toys in the bath, my son is quite content to sit quietly on his mother's knee as she dries him.

Bounce your flash off the wall or ceiling to avoid bright spots

In the photographs I've included here I've concentrated on the fun side of bathing, and have only included pictures of older babies, but you might also want to consider a series of photographs of your newborn child. As with any photographs of your baby, you can concentrate on taking an individual, memorable shot, or you can take a sequence of shots that tell a story when combined. For example, you could include a shot of a parent testing the temperature of the water, one of them supporting their baby in the water, another of the baby's towel and sponge, and so on.

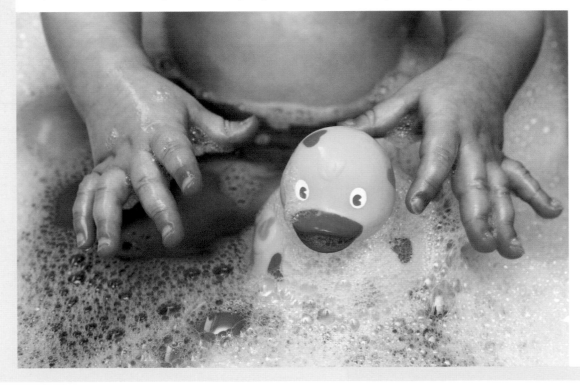

Left: This was taken with a 50mm standard lens at 1/40th of a second at ƒ8. In this instance, the relatively small aperture ensured that the bubbles and my son were both in focus.

Opposite page: There isn't a great deal of room in our shower so I took this one with a 17–40mm wide-angle zoom and used fill-flash bounced from the ceiling.

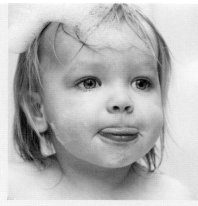

Far left: This was shot using a 24–70 mm standard lens at 70 mm, at a shutter speed of 1/40th and an aperture of ƒ5.6. One thing I would advise, especially with older babies, is to make sure that you stay out of reach when taking this sort of shot. If your camera is splashed while they are playing, it will survive, but if they grab hold of it and it falls in the bath it will probably be the end of it.

Left: This was taken at 70 mm, wlth a 24–70 mm zoom, and I used an aperture of ƒ5.6 to ensure that the detailing in the towel was sharp while letting the focus fall off in the remainder of the image.

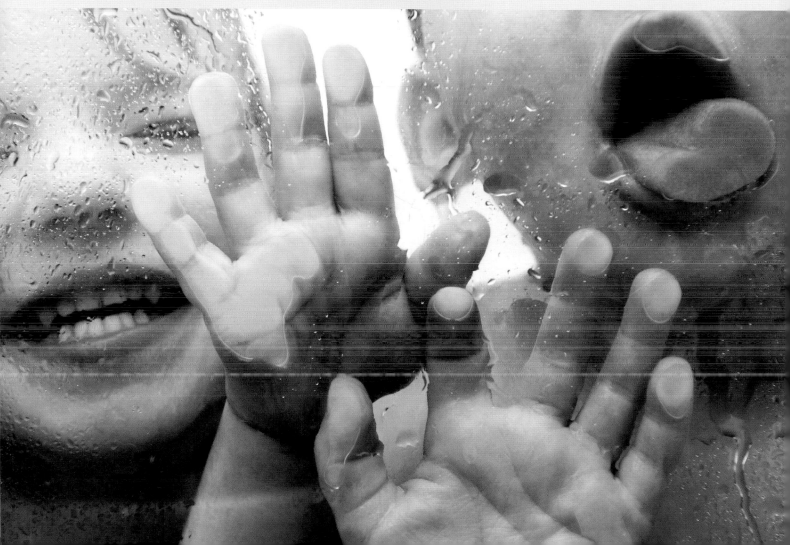

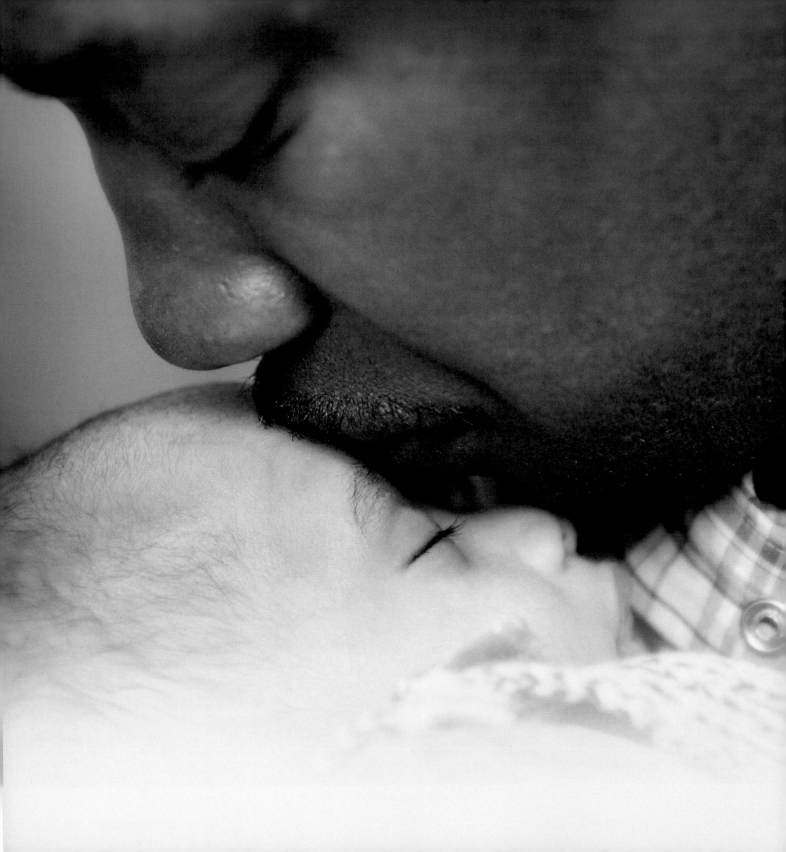

The word "pose" is all too commonly associated with family members forced to hold excruciating grins and stare into blinding flashes against their will. The results of holding your subjects hostage in this way are predictably dire, yet many photographers—even some professionals—persist in doing it. This chapter is all about finding other ways to capture images of those important groups while retaining life and character.

Poses

Late pregnancy

Hopefully, in the last few weeks before your baby arrives, you will have a bit of time to relax and will be able to spend some of it taking photographs. Once the baby arrives, things will be considerably more chaotic, but at this stage you can still take your time to think through the photographs that you would like to create.

For example, the image at near right taken when this woman was 38 weeks pregnant, and although it was taken in a hospital room, we had the time to think about how best to light the shot, how she should be posed, and so on. What this photograph also shows, unlike the other three included here, is the relationship between the mother and her unborn child. Clearly, any mother is linked to her unborn child, but this woman's quiet smile and downward glance tell you all you need to know about her feelings.

The alternative shot from the same shoot, opposite, has a much more graphic feel. Here the emphasis is on the bump itself, accentuated by the diagonal stripes of her dress. This approach is mirrored below in a shot which also concentrates on the bump, and even in the absence of the mother's face, the hands tell a story about the relationship between her and her baby.

The final photograph here, and the one taken most recently, shows our five-year-old and my wife. If you already have children, you will know that they can be fascinated by pregnancy, at least when they're old enough to understand what's going on, and this shot is typical of our older daughter's reaction as she "says hello" to her new sister.

My favorites from these four photographs are the first and the last, as both of these capture two things: the physical aspects of being pregnant and, more importantly, the emotions involved. The first is about the loving relationship this mother has with her unborn child, and the last is about one sister saying a gentle hello to another.

Try to capture the physical aspects of being pregnant and the emotions involved

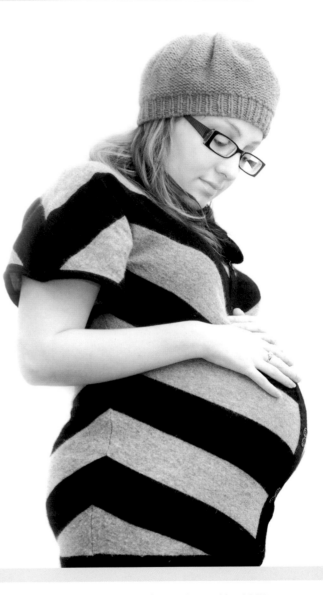

This image was taken at 46 mm with a 24–70 mm zoom at ƒ4.0. The lighting was a combination of window light, entering the room from the left, and flash, bounced from the top-right corner of the room. My aim, which was largely successful, was to balance the two light sources so that the image was evenly illuminated across the entire frame.

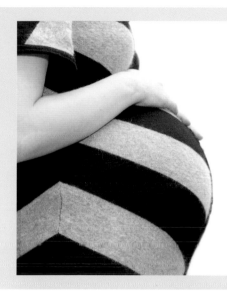

Using negative space in a photograph—the large white area covering the middle and right side of this image—can be an effective way of emphasizing the main subject within the composition. In this instance the negative space was produced by extending the canvas size in Photoshop, rather than by cropping the original. This is especially easy to do if you have a uniform background.

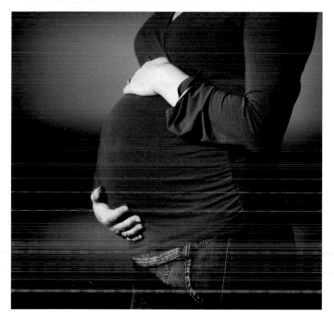

This picture was cropped from a portrait-format original and was shot at 200 mm using a 70–200 mm zoom. It was taken at ƒ2.8, to ensure that the background detail was out of focus, and was shot at 1/2000th of a second in bright sunlight.

An image taken at 145 mm with a 70–200 mm zoom lens using bounced flash as the main source of illumination. The benefit of using flash, rather than natural light, is that I could ensure that the various areas of the image were evenly lit.

Alone

In some ways it might seem a bit strange to have "alone" as the title for this set of images, as babies and young children are very rarely on their own, at least not physically. That said, they often seem to inhabit worlds of their own and can be oblivious to your presence and pretty much anything else that might be going on around them. For me, these are special moments, as they allow you a glimpse of what their world must be like, something that they're not going to be able to tell you about until they're quite a bit older.

The main image (opposite) is an especially good example, taken when our son was nine months old, and clearly shows his fascination with the grass. He spent ages crawling around, picking up leaves and bits of grass, appearing totally unaware of anything else going on around him. This shot was taken at around 200 mm, a focal length that allowed me to stay far enough away from him for him to not register my presence.

The image below left, which might be more aptly titled "distracted" than "alone," is another example of how a young child or baby, attentive one minute, can be totally distracted the next. It also illustrates an interesting point with respect to this sort of shot in that it would be rare to capture a photograph of this type where your child or baby was looking directly at the camera. More often than not, they'll be looking elsewhere, engaged in their own small world.

Superficially, the sand-play shot doesn't seem all that different in approach to the two I've just mentioned, but there is one important difference. If you look at the horizon in the background, you'll see that this one was taken at quite an unusual angle. In this case, I think it works because the emphasis is on the child at play. In other words, it's her world that's important—what she is doing—rather than anything to do with the general scene.

A dramatically different route is to adjust the main focus in sympathy with the child's, as in the image at top right. Our daughter, around eight months old at the time, was playing with the daisies in the grass and rather than take the obvious shot of her I decided to concentrate on the context instead, leaving her as a blurry and just recognizable figure in the background.

One thing you do need to bear in mind with this sort of shot is that it can take time to set up, not least because your child or baby needs to feel settled before they turn their attention away from you toward their surroundings.

These special moments allow you to take a glimpse into a child's own world

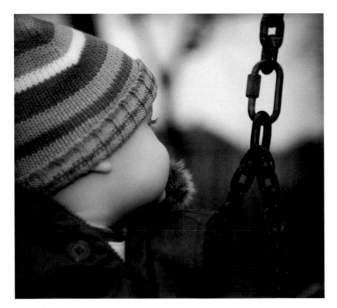

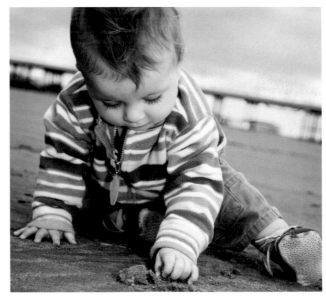

Opposite left: This was shot with a 24–70 mm zoom lens at ƒ2.8 and 1/250th of a second. As you can see, the depth of field is extremely shallow at this aperture, which draws your attention to the eyebrow and the line of the cheek. When taking photographs at such a wide aperture, especially if your subject is moving, take plenty of shots, as you can guarantee that a good proportion of them won't be in focus.

Opposite page right: This was taken at ƒ4.0 with a wide-angle 17–40 mm zoom with fill flash—used to balance the exposure of the foreground against the overcast but bright sky. The image was toned using the Curves tool to adjust the midtones of each of the individual RGB curves, increasing the Red and Green curves and decreasing the Blue curve.

Right: This shot was taken using the macro mode of a compact camera. Many compacts have a macro mode, and it's well worth spending some time experimenting with it as you can achieve some quite unusual results.

This was a relatively straightforward shot to post-process and didn't involve much beyond a minor increase in saturation (with the Hue/Saturation tool) and contrast (using the Curves tool).

Playmat

Playmats are a wonderful invention. When children are a few months old they become considerably more interested in their surroundings. Unfortunately, because they aren't especially mobile at this age, they can easily become frustrated at their inability to move or grasp objects that are out of their reach. Playmats remove these problems and provide a range of brightly colored and eye-catching items that are easily accessible. This also means that you will have plenty of time to take photographs while the playmat keeps them entertained.

The photographs included in this section cover a range of ways in which you can photograph your child on his or her playmat.

In the square-framed image I've attempted to capture the entire scene. The problem with attempting this sort of shot is that unless you're immediately above the center of the playmat, the edges of the mat won't be square with one another. In this case I fixed the problem in Photoshop by using the Skew tool (*Edit > Transform > Skew*). This allows you to drag the edges of an image to realign any vertical or horizontal distortions.

In the third and fourth I've focused on the toys hanging from the supports; on the solitary soft toy in the first image, with the young baby asleep in the background, and on a range of toys in the second shot. Finally I settled on focusing in on the baby, using the playmat as a simple and colorful background (below).

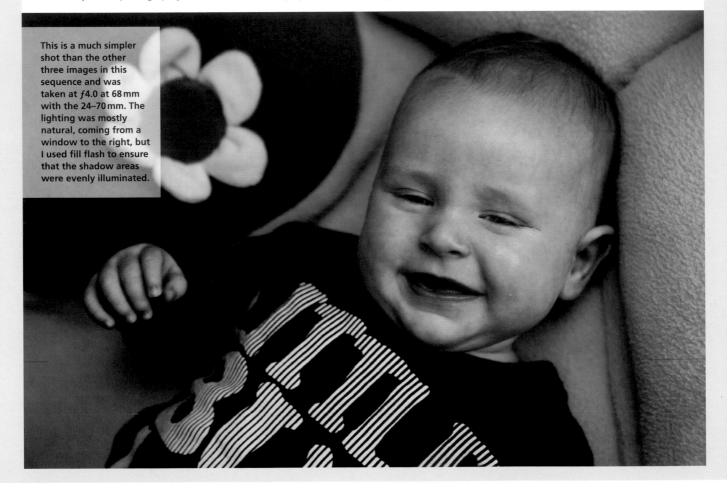

This is a much simpler shot than the other three images in this sequence and was taken at ƒ4.0 at 68 mm with the 24–70 mm. The lighting was mostly natural, coming from a window to the right, but I used fill flash to ensure that the shadow areas were evenly illuminated.

Above: This was taken at 24mm (with a 24–70mm zoom) at ƒ8.0 and the major source of illumination was flash, bounced off the ceiling.

Top right: This was taken with the same 24–70mm zoom, this time at 55mm at ƒ8.0. It's worth noting that the depth of field appears much shallower in this shot, despite the same aperture being used. This is because the focal point is much nearer to the camera—only a few inches from the front of the lens—hence the depth of field is considerably narrower.

Right: This shot used the same lens as the previous two images in this set but this time I used ƒ2.8, a much wider aperture. This ensured that the background details—the carpet and fireplace—were quite blurred. Had I used a smaller aperture, around ƒ8.0 to ƒ11.0, for example, these elements of the scene would have been much sharper and would have detracted from an otherwise simple shot.

Experiment with focus and aperture to achieve a range of different effects

Close up

Very young children, especially newborn babies, can seem incredibly fragile, and while some aspects of their early lives can be difficult to record, their fragility is relatively easy to capture. For me, there are two ways of doing this that work especially well. The first is to get in close, highlighting some small feature or aspect—a foot, an eye, their hands, and so on—and the second is to show them in relation to something larger; a point of reference that clearly highlights quite how small they are.

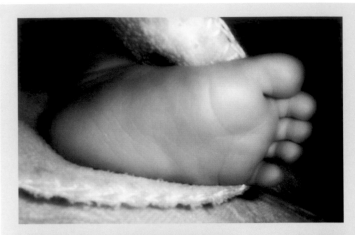

One problem with this type of shot, and one that will become immediately apparent if your baby is awake, is that babies rarely stay still. Unlike older children, they can't be posed, and their arms and legs seem to be in constant motion. One way round this is to take lots of shots, in the hope that at least a few of them will be successful. Another solution, and one that often works much better, is to wait until they are asleep. This way you can take your time in getting the shot exactly right. Three of the shots shown here were taken while one of our daughters was asleep: her foot at just under a month old, while she was asleep on the couch; her hand holding some cherry blossom while asleep in her buggy; and her eye when she was just over a year old. All three of these shots, in focusing in on the small details rather than the whole picture, clearly convey a sense of how tiny and vulnerable small children can appear.

Use a shallow depth of field to isolate and emphasize an area of the image

The shot opposite, of me holding the hand of our five-month old son, illustrates another technique that is useful for this type of shot, which is using a shallow depth of field to isolate an area of an image you want to emphasize. In this shot, the focal point of the photograph is his hand in mine. This emphasizes the disparity of hand size and the texture of his skin in comparison to mine. I could have taken this shot with a smaller aperture, but I don't think it would have been quite as effective because the other areas of the image would then compete for attention. This way, it's a simple image that clearly draws the viewer's eye to the contrast between the delicacy and size of his hand and mine.

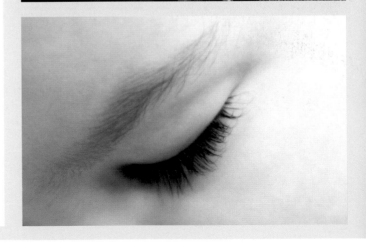

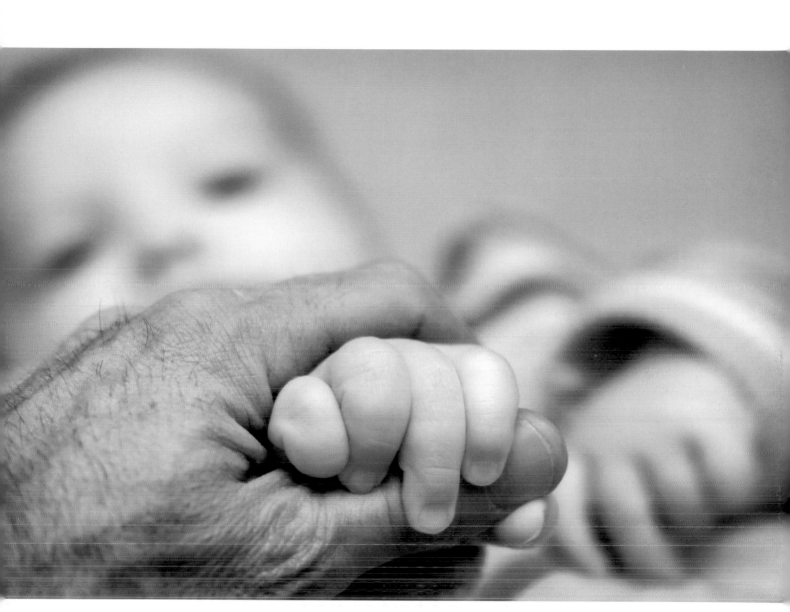

Top left: This shot was taken using the macro mode of a Fujifilm FinePix40i—a small, 2-megapixel compact camera. The lighting was natural—no flash was used—and the subsequent image was created by adding a Gaussian blurred layer over the top of the original image with the blend mode set to Overlay.

Middle left: This image was taken with a more recent compact with 5 megapixels. The post-processing involved a minor boost in saturation for the cyan and blue areas of the image.

Bottom left: Taken with the same camera, then converted to black and white using the Channel Mixer, toned with the Curves tool, and finished off by the addition of a Gaussian blurred layer over the top of the original image with the blend mode set to Soft Light.

Above: This was shot at ƒ2.8 with a 50 mm standard lens on a Canon 20D. Other than the black-and-white conversion using the Channel Mixer and the slightly warm tone (achieved using a Curve), very little was done to this image.

CLOSE UP

It would probably be fair to say that the mother-child bond forms the basis of one of the strongest and most enduring relationships we will experience during our lives. There are many wonderful moments that demonstrate it in early childhood, all of which provide numerous photographic opportunities that I couldn't possibly hope to cover here. What I have tried to include are shots that encapsulate a few of the things that I think are important.

Remain unobtrusive and you won't spoil the moment

The first is a shot of my wife with our youngest daughter, caught at around a year old. It clearly demonstrates the physical and emotional intimacy of their relationship. When taking this sort of intimate portrait it's often better to use a telephoto lens and stand at a distance rather than use a standard or wide-angle lens. It's much easier to remain unobtrusive, and not spoil the moment, if you're a little farther away.

The pair of shots at the top of the opposite page were taken moments apart during a portrait session. The primary aim of the shoot was to capture the mother with her daughter, pictured here, and her son, but in among the other shots were a few in which mother and daughter played together—and again, it's plain to see the strength and quality of their relationship in both these shots. Despite my advice in the last paragraph, both of these were taken with a wide-angle zoom. In this case, though, because I'd been taking photographs for at least 45 minutes, both of them were much more comfortable with my presence and less likely to become distracted.

I also used fill flash to balance the exposure on both these shots. On dull, overcast days it's often better to use a flash, otherwise you run the risk of either overexposing the sky or underexposing the shadow areas of an image, neither of which are ideal. A useful tip, if you can alter the setting on either your flash or your camera, is to dial back the amount of flash. Expensive flash units, and most DSLRs, will allow you to set a Flash Exposure Compensation value. I find that approximately -1/3 to -2/3 of exposure compensation produces a more natural-looking final result.

The final shot in this set was taken with a zoom lens and fill flash. The emphasis here isn't upon the interaction between this mother and her son, but it does speak volumes about their obviously close relationship.

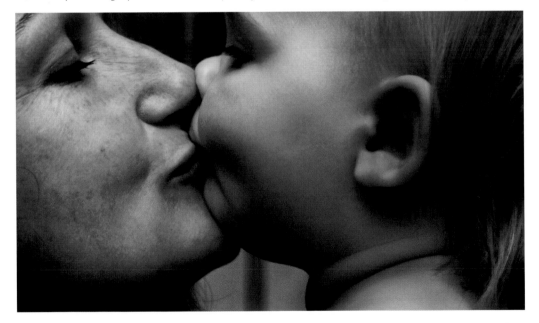

Left: This shot was taken with a compact camera and a good dose of luck. As those of you with compact digital cameras—especially older models—know, there is often a slight lag between when you press the shutter and when the shot is taken. This means that you need to be able to anticipate what will happen next—or simply shoot a few shots and pick the best, as I did here.

This was taken with a 17–40 mm zoom using fill flash. The post-processing was relatively straightforward, involving minor increases to the saturation and the contrast.

This was taken from a slightly different angle to the previous image, as you can see by the position of the horizon in each shot, but post-processed in an almost identical way.

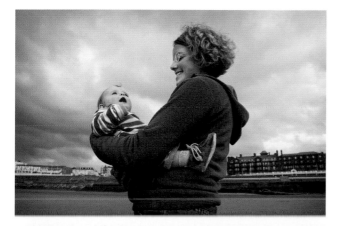
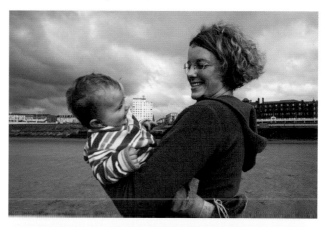

This shot was taken at 200 mm at ƒ2.8, and as you can see, the depth of field is very shallow, placing the emphasis on the child rather than his mother. Had I chosen an aperture of ƒ8.0 or above, both of them would have been in focus, but I suspect that the final image wouldn't have been quite as effective as there wouldn't be such a clear focal point.

Mother and Father

When I first started gathering pictures for this project, I found that this was the weakest area of my catalog, as I face surprisingly little demand for portraits including mother, father, and baby. Perhaps this is because many clients lead busy lives, and it was rare to find both parents at home when I arrived to photograph them. It also occurred to me that if you are buying this book to help you photograph your own children you will struggle to produce good photographs that include yourself. It's not impossible using a tripod and a remote release, but it isn't easy to produce something other than an obviously staged photograph.

With this in mind, I decided to include two other portraits, one of a father and son, the other of a mother and her son. In both, I've concentrated on capturing the gentle side of their relationship, and in this sense, both are very intimate portraits, and can be presented together. For me, a good portrait of a parent and child is one that clearly captures something significant about their relationship. In both these cases it's the love for their children that's most evident, but I could easily have focused on some other aspect of their relationship—having fun, playing, and so on.

Good portraits capture something significant about the relationship

If you're able to shoot the family group from the outside, the final two images here provide a great template for an unposed feel. Both of the same family, they tell a very clear story of the closeness of their relationships, achieved principally though the direction of eyelines. It's worth noting that in both of these images I chose to focus on the father. In the first, his attention is upon his wife (and, in turn, her attention is on the baby), while in the second he is focused on his daughter. In both, he provides a focal point around which the rest of the photograph is organized.

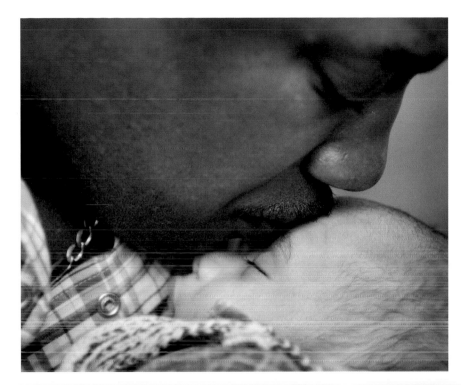

Opposite: This was taken using available light at an aperture of ƒ2.8, as I intended it to be a very soft and gentle image. The post-processing involved a black-and-white conversion using the Hue/Saturation tool, then the addition of some additional blur to soften the foreground detail, particularly the young baby's hair and eyelashes.

Left: The main source of illumination for this photograph was from an on-camera flash, bounced from the ceiling. The post-processing was relatively straightforward and involved little more than a black-and-white conversion using the Channel Mixer and toning the image with the Curves tool.

Bottom left: Both this and the next image were taken at an aperture of ƒ5.6 using a 24–70 mm zoom lens with a combination of window light and fill-flash. For both, I aimed to include the mother and baby at the edges of the image, but my main focus of attention was the father.

Bottom right: Having already taken the previous shot, I waited until the father turned his attention to his daughter before taking this one.

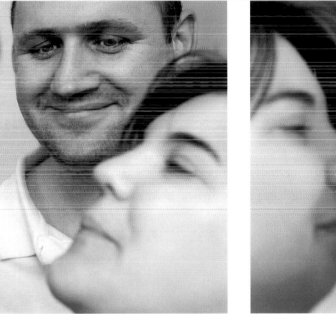

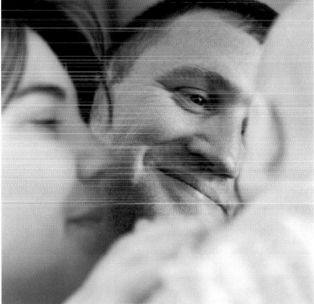

MOTHER AND FATHER

\mathscr{N}atural lighting

Unless you live in an especially temperate climate, when your children are very young you'll probably find that a good proportion of your photographs are taken indoors using flash and other sources of artificial light, in conjunction with whatever natural light is available. As children get older, and you spend more time out and about, you'll be able to shoot using entirely natural light. One of the major benefits of shooting with this light source is that you tend to get much faster shutter speeds than when using artificial light. For example, the shot to the right with the grassy background was taken at 1/800th of a second—more than fast enough to freeze a speeding one-year-old!

Light changes color at different times of day, so make sure you check your white balance

Another thing you need to consider is the direction of the light. In the beach shot the two adults' faces are partially in shadow, but the child's face is brightly but evenly illuminated.

One other aspect of natural light that you may need to consider, although we don't have the space to do the topic any justice here, is light temperature: the fact that the light changes temperature and color at different points during the day. It's much redder in the late afternoon and evening, and much bluer in the middle of the day. Typically, our eyes adjust to these differences, and we don't tend to notice them, but our cameras are more literal when they record a scene. Most digital cameras will perform well using their Automatic White Balance setting, producing reasonably natural-looking results, but if you do find that the colors seem inaccurate, it may be worth

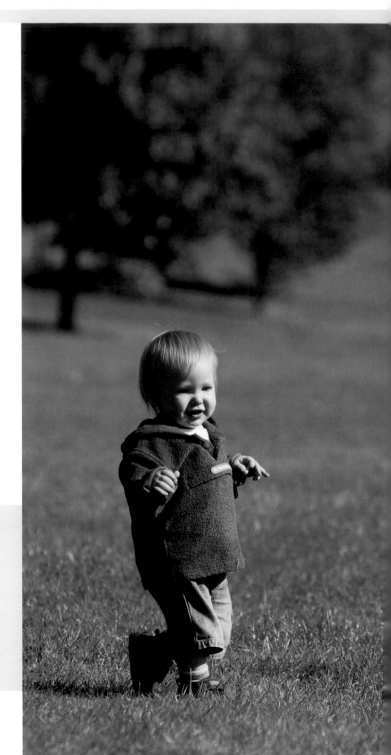

Taken at 1/800th of a second at ƒ5.6 with a 70–200 mm zoom. Very little post-processing was required other than a slight boost to the saturation. When taking shots in bright sunlight it's often better to slightly underexpose rather than go for the settings your camera suggests. An underexposure of around 1/3 of a stop will saturate the colors and help avoid blowing any highlights. If the image ends up too underexposed you can always make minor corrections in Photoshop when you edit the file.

changing the setting to one that more closely resembles the ambient lighting (sunlight, shade, cloudy, and so on). Alternatively, you can set a custom white balance using a reference card such as the WhiBal™ *(http://www.rawworkflow.com/products/whibal/ index.html)*. Using such a card ensures that the color balance of your images accurately reflects the ambient light.

It's also worth noting, especially when shooting portraits, that a dull day provides much better light than a bright, sunny one. Your subjects won't be squinting, their faces won't be partially obscured by shadows, and the lighting will be much more even. The image of the boy in a hat is a good example. It was shot on a very overcast day, which might not be ideal for a day out in the park, but is much better for photography.

The final image is also an example of diffused natural light, although in this instance the light was softened by the curtains in our daughter's bedroom. Again, this produces a much gentler image than direct sunlight

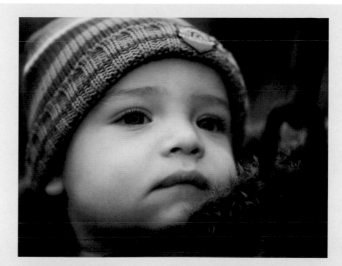

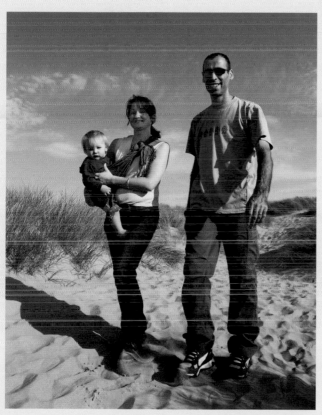

Above: This was taken with a 100 mm macro lens at an aperture of *f*4.0 and a shutter speed of 1/100th. As a final adjustment, the image was toned using the Curves tool.

Left: This was taken with a 17 mm zoom lens at *f*8.0, with a shutter speed of 1/500th of a second. As with the previous image, this didn't require any post-processing beyond a slight boost in contrast and saturation, achieved with the Curves tool and Hue/Saturation respectively.

Top: This was taken at 70 mm with a 24–70 mm zoom, with a shutter speed of 1/200th of a second and an aperture of *f*2.8. The post-production involved converting to black and white using the Channel Mixer and a boost to the contrast using the Curves tool. In this case, I wanted to deepen the shadows without losing any detail in the face.

*P*ost

Digital technology has given photographers more flexibility than was ever considered possible in the film era. You can now make any number of corrections to your images, or even replace or remove unwanted parts of the picture entirely. Not only that, but the distinction between color and monochrome images has lost its meaning, as conversion to any number of tones is child's play with Photoshop. This chapter provides just a few ideas which will help you give your photos a new lease of life. Better still, it's so easy to duplicate your original files that you can try any technique you like with no risk.

production

The essentials

The rest of this chapter deals with a variety of specific techniques that you can use to enhance and alter your images in Photoshop. On these first two pages, however, I want to briefly cover three more general points, all of which will enhance your images and workflow.

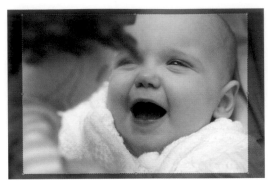

look much better), and so on. In these cases it can be a good idea to crop your image before doing any further post-processing. The easiest way to do this is to use the Crop tool.

Select the tool from the Toolbar and simply drag it across the image. When you release the mouse button, a dark border will be added to the area outside the selected crop, allowing you to easily preview how the final image will look. You can now resize or move the cropped area within your image. When you're happy with the crop, hit the Return key. The resulting image, as you can see below, is much better composed, with the distracting details on the right and lower sections removed.

THE CROP TOOL

In an ideal world, every photograph we take would be perfectly composed, but it's often the case that there is some distracting element around the edge of an image, or that the standard format of the image just doesn't suit the subject matter (perhaps a square image would simply

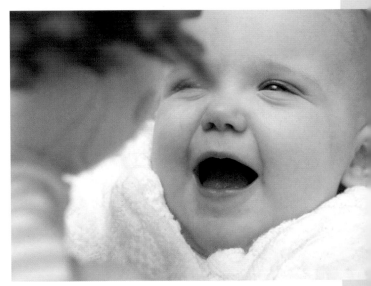

WORKING WITH ADJUSTMENT LAYERS

Generally, there are two ways in which you can implement most of Photoshop's Adjustment commands: via an adjustment layer, or directly via the Adjustments submenu (*Image > Adjustments*). For example, if you want to use the Black & White tool to convert an image to black and white, you can select this via the Image menu. Alternatively, you can use the Layers menu to add a Black & White adjustment layer. This creates a new layer in your Layers palette.

The second method is the one that I'd recommend, as it is a non-destructive way of editing your images. By non-destructive, I mean that the change is implemented via the adjustment layer, which can later be changed or removed, while the first method simply strips the color data from your image. As you work on an image, you may decide that you wish to alter an earlier step that you carried out during your post-processing. If you have implemented these steps via adjustment layers, it's a simple matter to change them. However, if you applied them directly to the image (via the *Image* menu) your options are much more limited.

Another benefit of using adjustment layers is that you can easily see the various changes you made to a document by consulting the Layers palette. As you spend more time editing an image, you can easily end up with quite a few adjustment layers: a Curves adjustment layer to increase the contrast, a Black & White adjustment layer, a Hue/Saturation adjustment layer to colorize your image, and so on, and it's easy to lose track of the various changes you made. By using adjustment layers, your document's structure and editing history is much more apparent, allowing you to easily remember the various changes that you made.

HISTORY PALETTE

An alternative way to undo any changes you make to your images is to use the History palette. By default, Photoshop will remember the last 20 actions that you carried out, and lists these in the History palette. In the example below, we can see that the image was first opened into Photoshop, then cropped, before being converted to black and white. To undo both of these changes, we simply need to click on the "Open" item at the top of the History palette list and the document will be returned to its initial state. This is especially useful if you want to return to an earlier part of the editing process and haven't saved the document.

These are only a few of the many invaluable techniques that Photoshop offers, and we will be covering more during the remainder of this chapter. To get the most out of this extremely powerful image-editing package, it is worth spending some time reading through the manual or consulting some of the many books and tutorials that are available, many of which are targeted specifically at photographers.

Using RAW

When shooting JPEG images, a great deal of processing is done by your camera before you can preview the image or export it to your computer. Typically, this processing will include setting the white balance, changing the color saturation and contrast, converting the original 12- or 14-bit data to 8 bits, and sharpening the image. A RAW file, on the other hand, consists of the raw data supplied by your camera's sensor, and any changes to white balance, saturation, contrast, and sharpness are applied—when you use a RAW converter to process the file and save the image as a TIFF or JPEG. All DSLRs, most prosumer models, and some digicams can shoot in RAW format.

Using RAW files rather than shooting in JPEG does require an extra step on your part—the RAW conversion process—but it's a step that many photographers are prepared to take as it often results in higher quality images. There are a number of reasons for this:

- The white balance can be set to any value, not just discrete values like "daylight" or "cloudy." This allows for much greater control over the final color balance of your image.
- The various conversion settings can be changed after the shot is taken. This allows for much greater flexibility when post-processing your images.
- RAW files, whether 12- or 14-bit, store more data than 8-bit JPEGs. This means that RAW files contain more detail with respect to both luminosity and color data.
- RAW files are either uncompressed, or compressed using "lossless" algorithms, while JPEG compression always involves the loss of some data.
- You can use different conversion engines/software to produce your JPEGs or TIFFs, not just the one incorporated in your camera.

Whole books have been written on the subject of RAW conversion, so I can't possibly do full justice to the topic here. What I can do is introduce you to the Adobe Camera Raw engine, the RAW conversion component of Photoshop, and show you a few of the basic things you can do.

While you can open RAW files in Photoshop—double-clicking a RAW file will launch Adobe Camera Raw—it's often much easier to preview your images first, using Adobe's built-in file browser, Bridge. This provides you with a set of thumbnails and a larger preview and the shooting data for the image you select.

When you've decided which image you want to work on, double-click on it. This will launch Adobe Camera Raw, the engine that will convert your RAW file to either a TIFF or JPEG.

As you can see below, there is a wide variety of settings, even on the first "Basic" tab, and there are another six tabs to explore (for setting the tone curve, converting to grayscale, split toning, sharpness, lens corrections, and camera calibration). In the first example I've made a couple of changes, the most significant of which was to alter the Fill Light slider. As you can see, this adds details to the shadow areas of the image.

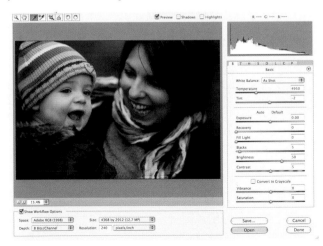

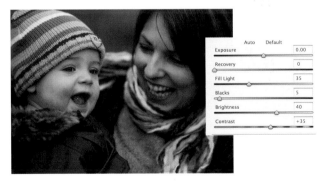

My advice, if you want to make the most of your images—both in terms of control over their final appearance and their quality—is to spend some time working with the RAW format, as the results can often be dramatically better than if you had shot the original as a JPEG.

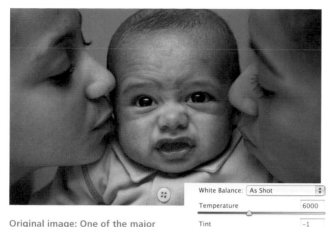

Original image: One of the major
benefits of using RAW is that you
can be much more precise about the
color balance of a shot. Here, the original shot is far too "warm"—
the camera's automatic white balance didn't do a very good
job of evaluating the color balance of this scene.

2 The Temperature and
Tint were both changed
automatically, and the preview
image shows that the colors are now much more natural.

1 The easiest way to fix the color balance with Camera Raw is to use
the Eyedropper tool to click on a neutral area of the image—that is,
something that would naturally be white or gray. In this image, the only
suitable areas were the whites of the baby's eyes, so I zoomed in and
clicked on one of them.

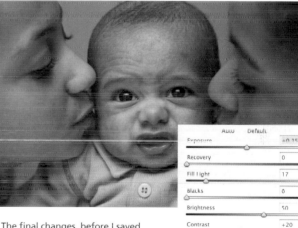

3 The final changes, before I saved
the file as a TIFF, were to increase the
Exposure by a small amount, add some
Fill Light, and fractionally reduce the Contrast.

Redeye removal

Redeye, which occurs when the light from a flash unit is reflected from your subject's retina, can ruin an otherwise perfectly pleasant photograph. It is an especially common problem with compact cameras because the flash is often very close to the lens, but it can also occur with DSLRs when you use a camera-mounted flash unit and a telephoto lens. In other words, if the angle drawn between the flash unit, your subject's eye, and the lens is small, you will probably finish up with redeye. The example used here was taken with a Sony Cybershot T9, a six-megapixel digital compact. In most respects this is a great little camera, but because the flash and the lens are no more than half an inch apart, redeye is almost inevitable if your subject is looking straight at the camera.

The good news is that redeye is extremely easy to fix, especially since Photoshop CS2 introduced the Red Eye Tool.

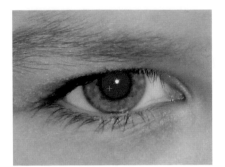

1 Zoom into an affected eye using the Zoom tool, or by pressing and holding Ctrl(⌘)+Space (which temporarily invokes the Zoom tool), and drag a rectangle around the eye area.

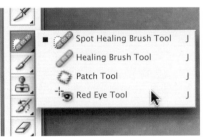

2 Select the Red Eye Tool, which is found in the Healing Brush Tool's flyout menu.

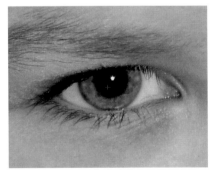

3 Click anywhere within the red area of the subject's eye. Here, one click with the tool was sufficient to remove all traces of redeye. Repeat this with the second eye and your portrait is transformed (right).

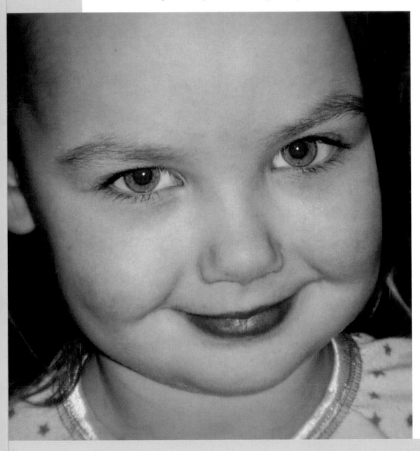

To avoid redeye in the first place, you need to increase the angle between your lens and flash unit. With compact cameras this often isn't possible, but most prosumer models and all DSLRs allow you to attach an external flash unit. With one of these attached, the angle is much greater because the flash head is typically around six inches away from the lens. In other words, any light entering your subject's eyes will be reflected away from the lens, not directly into it.

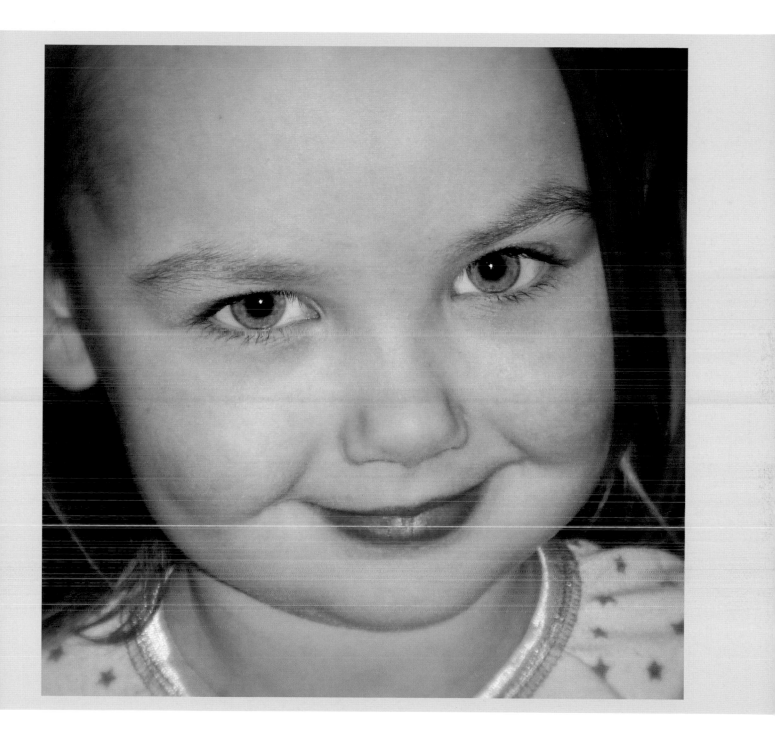

REDEYE REMOVAL

Removing unwanted detail

Over the next few pages we're going to look at a variety of techniques and tools you can use to repair and enhance your photographs. These processes will create a more aesthetically pleasing final result from a flawed original image. The tools we are going to focus on are the Spot Healing Brush, the Patch tool, and the Clone tool, but we're also going to discuss using the Curves tool to enhance various aspects of your photographs. In this first section we're going to focus on several different methods you can use to remove unsightly details from your images.

Create an aesthetically pleasing result from a flawed original

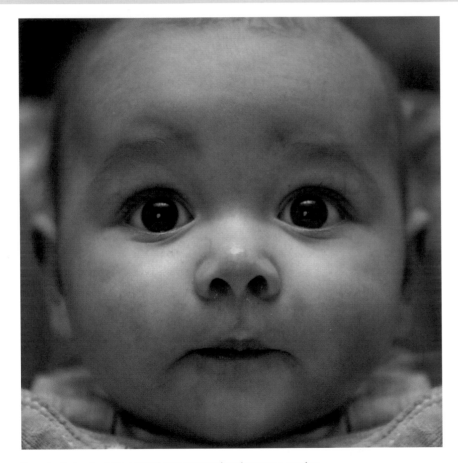

If you look closely at the original, you can see that there are a number of problems, including some rather distracting catchlights in the baby's pupils; some small but distracting reflections under his nose; a bright spot on the end of his nose, and some bright patches on his cheekbones. None of these are major problems, but their removal will improve this photograph quite considerably.

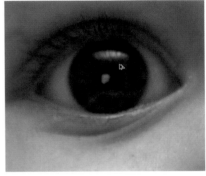

1 The extra catchlights in the baby's pupils are very easy to remove and can be painted out using the Brush tool. First, use the Eyedropper tool to sample the color of his pupil.

2 Next, using a small brush of around 25px, simply paint over the reflections.

3 The next stage, fixing the small reflections under the baby's nose, is equally straightforward. This time, select the Spot Healing Brush and set it to a diameter of around 20px.

4 Click on each of the small reflections. As you do so, Photoshop removes them by smoothing over that area and blending it into the surrounding image.

5 The bright patch on the end of his nose is better suited to the Patch tool. First, make sure that you click the Source button in the Toolbar. This tells Photoshop that you are going to select the area that you want to patch and then repair it, rather than vice versa. Next, draw around the area you want to fix, leaving a small margin.

6 Next, you need to drag the selection to the area of the image that you're going to use to repair the selected portion of your image. It's the texture, rather than the color, that you should be targeting.

7 When you release the mouse button, the original area will be replaced with the area you selected, and the new area will be blended seamlessly with the remainder of your image.

8 The final areas of the image we're going to look at are the rather bright patches on the baby's cheekbones. These could be patched too, but the Clone Stamp tool is a better choice. In the Tool Options Bar, set the Mode to Darken rather than Normal. Hold down the Alt (⌥) key and click in the darker area below the bright spot on his cheek.

9 The last step set the source point from which the Clone tool will sample. Now, paint over the bright area. Any areas that are brighter than the source area will be darkened, while any darker areas won't be changed.

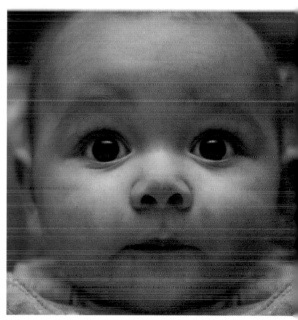

As you can see, we now have a considerably better image than the one we started with. However, there's still some way to go, so we'll continue on the next page.

Polishing features

Having removed the small blemishes and hot spots from this image (see page 84), we're now going to perform some further enhancements that will dramatically improve the final result. I'll begin by performing a simple black-and-white conversion, but the most important tool here is Curves. (For more on the Black & White tool, see page 92.)

Curves adjustment layers are even easier to experiment with since the histogram was added

1 Go to *Layer > New Adjustment Layer > Black & White…* and select the Red Filter. As you can see, this converts the image to black and white by lightening the red and yellow tones in the image and darkening the cyans and blues. This smoothes out some of the remaining irregularities in the baby's skin and focuses the viewer's attention on his features, not the background.

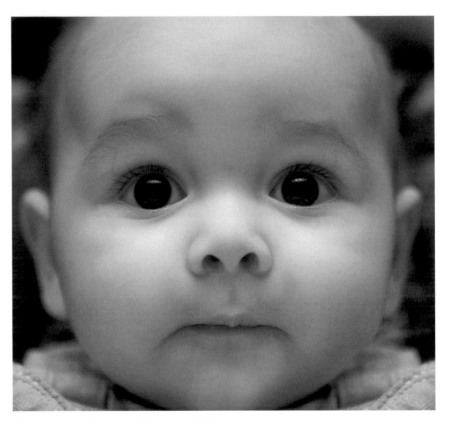

2 There are two things you might notice at this point. First, the image looks a little dark, and second, his cheeks and the bridge of his nose still look rather bright in comparison with the rest of the image. We can fix both of these issues using the Curves tool. To create a Curves adjustment layer, go to the Layer menu and select *New Adjustment Layer > Curves….* This will bring up the Curves dialog, in which you can alter the tonal range of the image.

Curves 3

9 Now, use the eraser, set to around 30px, to erase the areas of the mask that cover his eyes. As you erase these areas you'll see that the mask icon in the layers palette will gradually be erased. As you can see, this makes a dramatic improvement to the image, and really focuses the viewer's attention.

3 In this instance I used three control points, created by clicking on the Curve, to alter the tonal balance of the image. The first, in the bottom left of the dialog, deepens the shadows by a very small amount.

4 The second, in the middle of the Curve, lightens the midtones—in this case, most of his face, other than the deeper shadows and the bright areas across the top of his cheeks and the bridge of his nose.

5 The third and final point, at the top right of the Curve, ensures that the highlight areas of the image aren't brightened. The net result is that the range of tones across his face is much more evenly distributed and the bright areas blend in rather than stand out.

7 Next, you can drag this point to alter the Curve and lighten the whites of his eyes.

8 This process left the baby's eyes looking rather too bright overall, so I added another two points to darken his irises and pupils.

6 Create another Curves adjustment layer, then set a control point for the lightest part of his eye. You can do this by Ctrl(⌘) +clicking on a specific area, after which a control point will be added to the Curve.

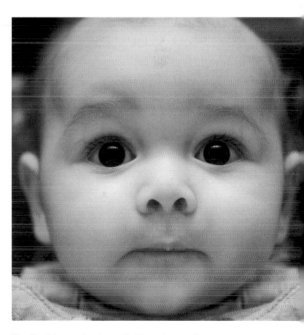

The final image has been lightened overall and the tones of the baby's face look much more even. The whites of the eyes have been accentuated, pulling the viewer's gaze into the portrait.

kin tones

One of the great benefits of using a digital camera, as opposed to a film camera, is that it can automatically adjust its white balance to produce natural-looking photographs under a variety of different lighting conditions. Every once in a while, though, the camera doesn't get it right, and you will need to do some extra work to adjust your image. This is especially important with portraits, as an incorrect white balance can play havoc with your subject's skin tones.

3 The Curves tool adjusts the individual color channels to convert the appearance of the point you clicked to a neutral tone. In this example it has raised the amount of blue in the image, lowered the amount of red, and made a barely perceptible change to the green channel.

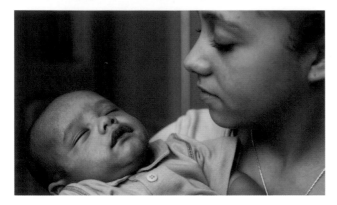

In this example the image is noticeably too "warm," with color tones skewed toward the red end of the spectrum. One easy way to adjust this image is to use the Curves tool to alter the color balance.

1 First, create a new Curves adjustment layer. You will be presented with a new Curves dialog. Click on the midtones eyedropper icon in the center of the row of three beneath the curve.

2 When you click anywhere within the image using this eyedropper, you tell Photoshop that the point that you clicked is of a neutral gray color. Click on something appropriate—in this case, a white doorframe.

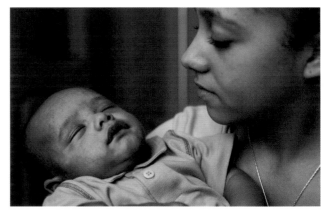

The Curve is applied by clicking the OK button. The image now looks a lot more natural, and is far closer to the true skin tones.

An alternative method—especially useful if there isn't a neutral gray point in your original image—is to use the Photo Filter tool to change the color balance of your image. Like Curves, this can be applied as a non-destructive adjustment layer accessed via the Create new fill or adjustment layer icon at the bottom of the Layers palette. In this example, as the original is much too warm, you need to select a cooling filter. I chose the Cooling Filter (82) option. As you can see, applying this filter creates a much more natural-looking image.

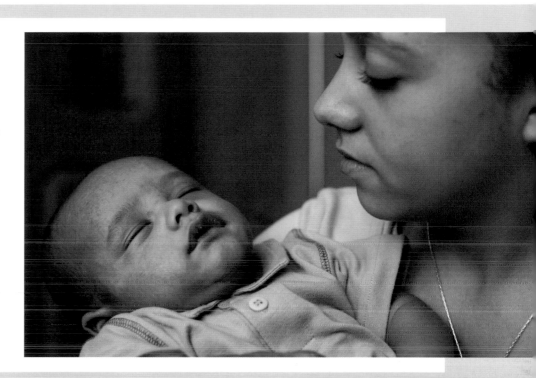

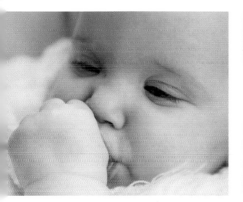

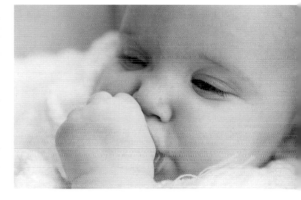

You can also use the Photo Filter tool to warm up an image. In this example, shot by the light of a north-facing window, the image looks cold, with a predominant tone of blue.

1 To warm things up, create a Photo Filter adjustment layer (as described above) and select one of the warming filters. I chose Warming Filter (85). The final image is a considerable improvement on the original.

2 For a stronger effect, try increasing the density to 50%. In this example, I don't think this is as effective, but it is something you can experiment with to create a variety of effects.

\mathcal{S}oft-focus effects

Soft focus is a technique often employed by portrait photographers as it adds a diffuse, almost dream-like feel to an image. It's also a useful for hiding minor imperfections in both skin tone and texture, both of which can enhance your photographs of your baby or young child.

There are a variety of ways to achieve this effect, either as the shot is taken, or later in Photoshop. The first in-camera technique is to use a wide aperture, as in the first shot shown below. This was taken at ƒ1.6 with a 50mm standard lens and the very limited depth of field gives the image a soft and gentle feel. A second

technique, not illustrated here, is to place something between the lens and your subject that will diffuse the final image: a soft-focus filter, a clear filter smeared with Vaseline, or a piece of fine gauze.

The third method is to use a soft-focus lens. The second image below was taken with a Canon 135mm ƒ2.8 soft-focus lens, the only soft-focus lens currently being made for 35mm cameras. The results are beautifully soft and diffuse. This lens allows you to set a variable amount of soft focus and can produce wonderful pictures, but it isn't especially cheap, and the effect is one that can be mimicked quite accurately in Photoshop, as we will see.

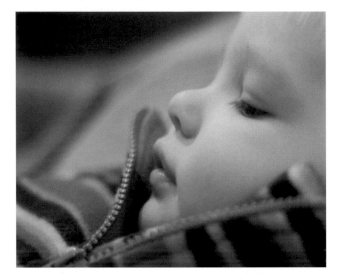

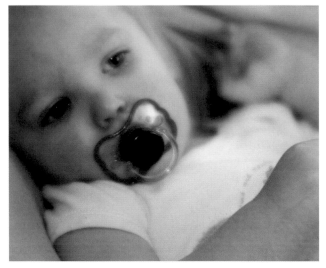

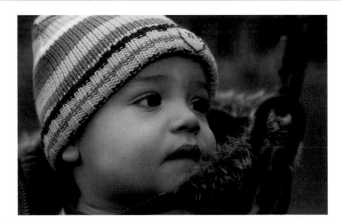

1 Duplicate the background layer. In the layers palette, right-click the background layer and select Duplicate Layer…. Call this layer "Blur," or something else that will identify its function if you edit the file later. At this stage all you have done is copy the existing image, so nothing looks different.

Soft focus adds a diffuse, almost dream-like feel to your images

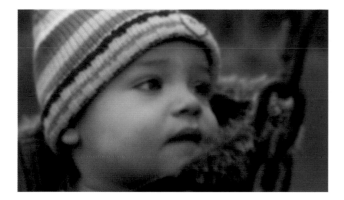

2 Go to *Filter > Blur > Gaussian Blur* and set a radius of 15 pixels. This leaves you with a very blurred version of the original shot.

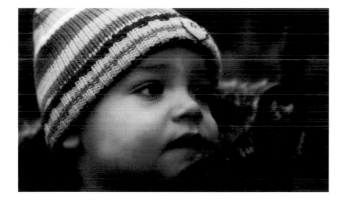

3 Change the blend mode of this layer to Soft Light using the drop-down menu in the Layers palette. At this stage you begin to get an idea of what the final image will look like.

For a more pronounced effect, set the blend mode of the blurred layer to Overlay rather than Soft Light. This works especially well for images that lack contrast, but for images with a wider dynamic range you will probably find that the highlights and shadows become too pronounced.

Overlay final

4 The image may look a little dark. This can be corrected with a Curves adjustment layer. Create one by selecting *New Adjustment Layer > Curves...* from the Layer menu, and adjust the image accordingly. I lightened the shadow and midtone areas, but kept the highlights at much the same level.

5 My final adjustment was to use the Hue/ Saturation tool to increase the saturation by +10. The final image, as you can see below, is considerably softer than the original.

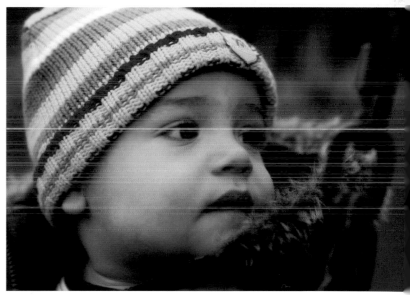

Soft Light final

Black and white

The world's first photograph, taken in 1826 by Nicéphone Niépce (1765-1833), was a black-and-white image, produced using a form of asphalt which hardened on exposure to light. Since that time, despite the advent of color photography, black-and-white photography remains a firm favorite with many fine artists and master photographers. A large part of its appeal lies in its classical and elegant simplicity—a photograph is reduced to the interplay of nothing more than light and dark, shape, form, and content—and it is a form of photography that remains particularly popular for weddings, portraiture, and photojournalism.

More practically, converting an image to black and white can often transform a drab color picture into something more spectacular, or simply more visually pleasing, and there are a variety of ways this can be achieved in Photoshop. Perhaps the simplest is to use the Desaturate command. This removes all color information from your image using the luminosity of the different areas of the image (just as reducing saturation to zero in the Hue/Saturation dialog does). However, this is a rather crude technique that doesn't offer a great deal of control, and if you want to make the most of your images, a much better method is to use Photoshop's Black and White conversion tool.

When you bring up the Black and White conversion dialog (*Layer > New Adjustment Layer > Black and White…*) you are presented with six sliders representing the six main colors on the color wheel. If all of these sliders were set to 50%, you'd see exactly the same result as if you'd used the Desaturate command, but they're not. That's because the default option is to adjust the bias in a way that is generally more pleasing.

That selectivity is also the approach taken by the *Image > Convert to Grayscale* command, which converts to black and white but takes more detail from the reds than the blues because this tends to favor

faces. What Black and White adjustment layers do is take that principle and, rather than following a predetermined formula, allow you to make the choice yourself. This is nothing new—in fact, it's the essence of black-and-white photography. Traditionally, of course, the biases were achieved with a colored filter over the lens—a nod to which is included in the form of the Preset drop-down, which includes traditional filters. Now you are able to make these changes yourself, with the huge advantage of a live preview. The technology has changed, but the principle remains the same. You must decide on the most artistically pleasing treatment in monochrome.

Default Black and White settings

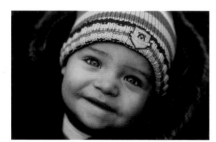

The original color image

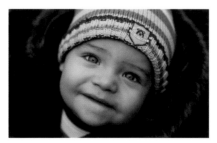

All color information from the image removed using the *Image > Adjustments > Desaturate* command. The result is an acceptable, if rather uninspired, black-and-white photograph.

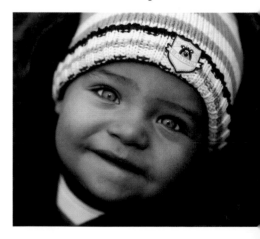

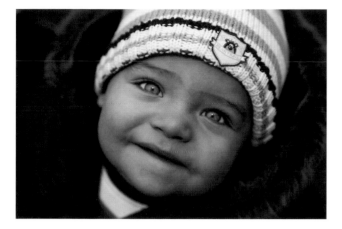

This image is created using the standard Blue Filter (Reds, Yellows, and Greens all set to 0% and the Cyans, Blues, and Magentas boosted to 110%). The result isn't attractive, but it demonstrates how the various settings work. The child's hat, predominantly blue and cyan in the original, has become very light, and his face, mostly comprised of colors in the Red and Yellow range, has become unrealistically dark.

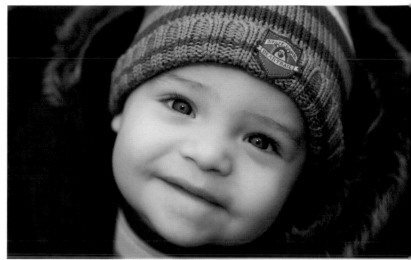

The Red Filter, conversely, emphasizes the Reds, Yellows, and Magentas, while the Green, Cyans, and Blues have been considerably reduced. The result is far better than any of the previous options. Here, the child's hat has been toned down and doesn't dominate the image, his face is much lighter, and his eyes appear much more natural. In other words, the setting has emphasized the important areas of the image—his face and features—while minimizing the other elements of this scene.

To boost the tones in one particular area of your image, try this alternative Photoshop method.

1 Create a Black and White adjustment layer as usual. Move the cursor over the area of the picture you'd like to concentrate on. Click and hold.

2 Photoshop automatically identifies which of the six color groups is beneath the cursor when you first click. Without releasing the mouse button, drag the cursor left or right.

3 Dragging has the same effect as dragging the equivalent slider in the Black and White dialog box—indeed the result is reflected there, too. Release the mouse button when you're happy with the change.

This method makes it easier to concentrate on the parts of the picture, rather than the color groups, that you want to target. Here, dragging the mouse has dramatically lightened the rim of the hood.

| Yellows: | 240 | % |

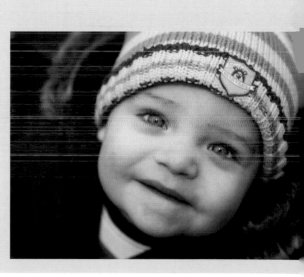

BLACK AND WHITE

Toning images

Toning your images can be a highly effective technique for enhancing your photographs, especially for black-and-white images. There are a variety of tools you can use, perhaps the simplest of which is the Hue/Saturation tool.

To use this tool, create a Hue/Saturation adjustment layer from the Layers menu (*Layers > New Adjustment Layer > Hue/Saturation*), and check the Colorize box. Adjust the Hue slider until you find a color or tone that you're happy with—in this example I chose a cold, blue tone. Then adjust the Saturation slider to alter the intensity of the effect.

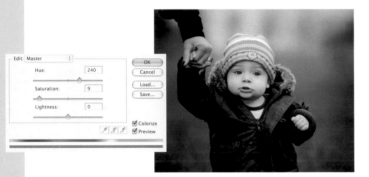

Another simple toning method is to use the Black and White tool. Create a Black and White adjustment layer (*Layers > New Adjustment Layer > Black & White*) and click the Tint radio button. This works in much the same way as the Hue/Saturation tool—you can adjust the Hue slider to change the color, and the Saturation slider to adjust the extent to which the Hue affects the image. This time I chose a red/purple hue for the image.

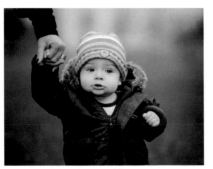

A more complicated procedure, but one which offers much greater control over the final appearance of the image, involves using the Curves tool to adjust the three RGB channels independently.

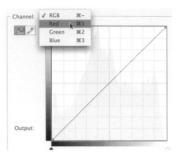

1 First, create a Curves adjustment layer (*Layers > New Adjustment Layer > Black and White*), then switch to a specific color channel using the drop-down menu at the top. Next, you need to adjust the Curve for this channel. Do this by clicking and dragging the midpoint of the Curve.

2 I increased the midtones in the Red channel by dragging the curve slightly upward in the center.

3 I made a similar adjustment to the the Green channel, and decreased the midtones in the Blue channel by dragging the curve downward. Choose RGB from the drop-down menu to see all three plotted channels against each other.

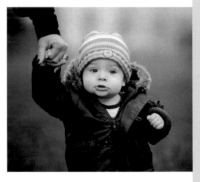

These settings produce a warm, sepia-like tone. To increase the intensity of the effect, simply drag the individual curves a little farther from the midpoint.

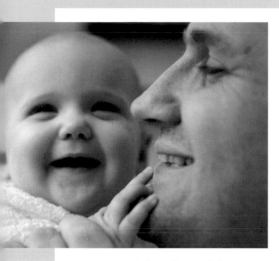

The curves technique discussed above can also be applied to color images, but in the example included here I've gone for a more dramatic change, from an image with "correct" tones to one with a cross-processed feel.

1 I first adjusted the Green channel (as described above) by introducing two adjustments. The first, towards the bottom-left of the Curve, decreases the amount of green in the shadow areas of the image, while the second increases the greens in the mid-tones and the highlights.

2 Next, I altered the Blue channel. In this case I decreased the amount of blue in the highlights, kept the mid-tones much the same as the original, and increased the amount of blue in the shadow area of the image.

3 I didn't change the Red channel, but did use the RGB composite curve to increase the contrast of the image. Finally, I increased the overall saturation of the image using the Hue/Saturation tool, and added a slight vignette to darken the edges of the image.

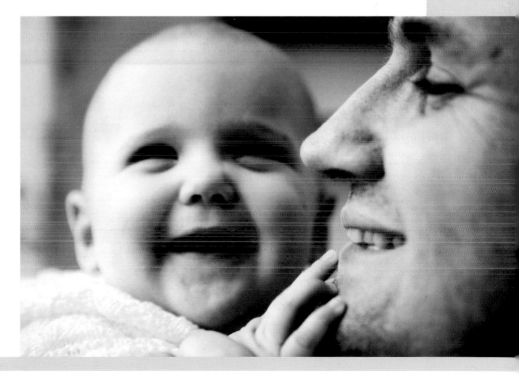

Enhancing color images

When you're shooting under flat lighting conditions—on dull gray days, for example—you will often find that your photographs lack impact. They may lack contrast, color saturation, or both. Increasing the contrast in an image using the Curves tool is relatively straightforward, but increasing the color saturation can be a bit more complicated.

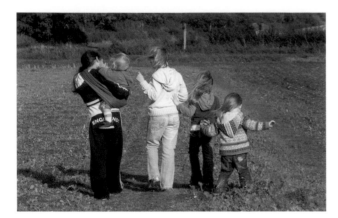

This scene contains a wide range of colors, but they are all quite muted. The quickest and easiest way to enhance the saturation of an image is to use the Hue/Saturation tool.

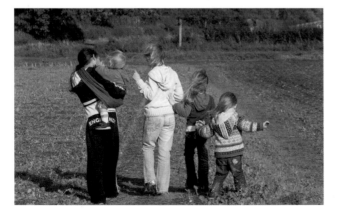

1 Create a new Hue/Saturation adjustment layer. To test the water, adjust the Saturation slider to +50. The image, at least at first glance, looks considerably better.

2 Using the Zoom tool, scan over the boosted image and look for any problem areas. In this example, the global increase in saturation has blown out a lot of the details in the predominantly red areas of the image. This is particularly noticeable on the sleeves and hood of the pink shirt.

3 To overcome this problem we can adjust the various colors in the image on a color-by-color basis. To do this, reset the overall Saturation adjustment, and then select Reds from the drop-down menu.

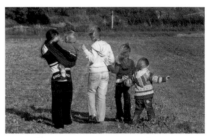

+100 Red saturation

4 A quick way to preview the extent to which an individual color will affect the image as a whole is to dramatically alter the saturation to either +100 or -100. Start by dragging the slider to +100.

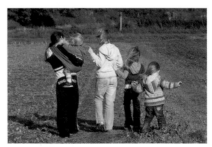

-100 Red saturation

5 Now go to the other end of the scale. This will give you a good idea of the areas of the image that will be affected by any changes that you make.

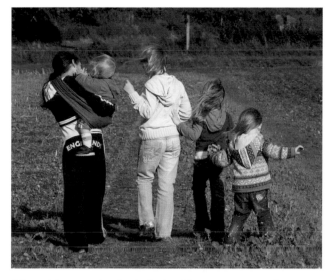

6 Amend the saturation for the Reds, taking care to preserve image detail. With that in mind, the maximum Red saturation for this image is +15. As you can see, though, this doesn't significantly alter the original image, so we now need to turn our attention to the other colors.

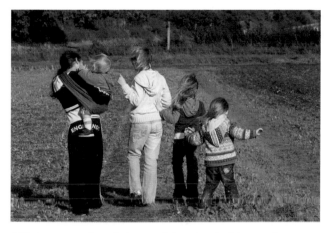

8 Work your way through the rest of the colors. In this example I increased the saturation of the remaining colors by the following amounts: Greens +55; Blues +50; Cyans +35; Magentas +50. The end result is a considerable improvement on the original.

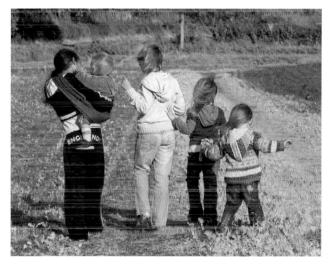

7 Following the same principle as in steps 4 and 5, if we increase the saturation of the Yellows to +100 we can see that this color that will significantly affect most areas of the image. Edge the slider back until the color is boosted without degrading the image or losing any detail. I found that +60 was about right.

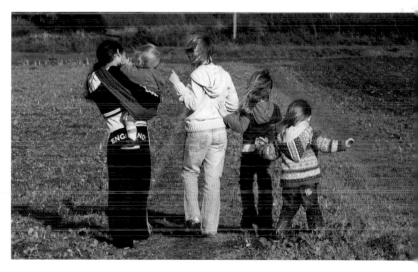

Finally I increased the contrast a little using the Curves tool. This wasn't a radical change, but it made the subjects stand out from the background a little more clearly.

Selections

When working on an image, you may decide that you want to modify a specific area of that image. In this example, of a shot of my young daughter's shoes, I decided I wanted to change the shade of the background to avoid the color of her shoes merging with the color of the wooden floor.

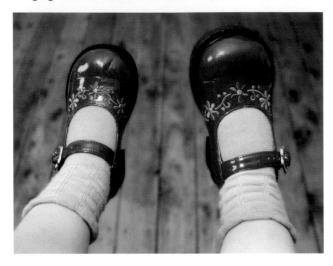

There are a variety of tools you can use to create a selection, but as this example has clearly defined edges, the obvious choice is the Magnetic Lasso. Unlike the standard Lasso, the Magnetic Lasso "clings" to sharp edges in an image to help you select the desired area.

1 Click somewhere on the edge of the area you want to select, then move the pointer along the perimeter. As you follow the edge of an object with the tool, you will see that Photoshop adds a series of anchor points, defining the edge of the object you are tracing.

2 On your journey around the object you'll reach some places where you'll be absolutely confident about where the anchor point should be. Click on one of these places to guide the line.

3 If the automatic selection goes the wrong way, press the Delete key (which removes the last anchor point) and track back with the mouse. As you go over the image a second time, add more of your own anchor points.

4 When you reach the limit of your desired selection, move the tool into the border and click. This will manually add an anchor point and you can move along the border until you reach the point at which you wish to continue defining the selection.

Feather Selection

Feather Radius: 2 pixels

OK
Cancel

5 Even the most accurate selection often benefits from some degree of softening. To do this, click *Select > Modify > Feather*. This softens the edge of the selection so that it appears seamless when further adjustments are made to the image. A Radius of about two pixels should be sufficient.

Save Selection

Destination

Document: CRW_1647_RT16.tif

Channel: *New*

Name: left leg

OK
Cancel

Operation

- ● New Channel
- ○ Add to Channel
- ○ Subtract from Channel
- ○ Intersect with Channel

6 In this example, because there are two areas we need to select (both legs), it's a good idea to save the first part of the selection. It's not essential—pressing Shift as you start to draw a new shape allows you to add to the selection—but it does protect you from having to start again if you make a mistake. Go to *Select > Save Selection* and name your selection.

Load Selection

Source

Document: CRW_1647_RT16.tif

Channel: left leg

☐ Invert

OK
Cancel

Operation

- ○ New Selection
- ● Add to Selection
- ○ Subtract from Selection
- ○ Intersect with Selection

7 Draw a selection around the other leg in the same way. Then, with that selection still active, go to *Select > Load Selection*. You'll find your previously saved selection in the Channel drop-down menu. Set the Operation to Add to Selection and click OK.

Layer 1

Background

8 To separate the legs from the layer beneath, go to *Layer > New Layer via Copy*. The selected area of the image will be copied onto a new layer.

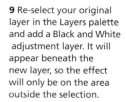

Layer 1

Black & White

Background

9 Re-select your original layer in the Layers palette and add a Black and White adjustment layer. It will appear beneath the new layer, so the effect will only be on the area outside the selection.

The resulting image contrasts the red shoes with a tinted monochrome background.

New backgrounds

Adding a new background to an image isn't something I'd particularly recommend—it's time consuming and the results are rarely 100% convincing—but rare occasions, when you do have an image that you particuarly like, it can be worth the effort. In this example, of a father feeding his 11-month-old son, the mirror, radiator, and door are all distracting elements. By removing them, the image is greatly improved.

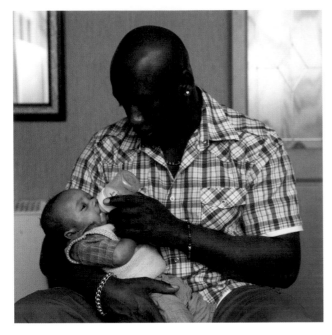

There are several ways to replace a background, but the most straightforward, and the one that generally produces the best results, is the Extract tool. Before you begin, duplicate the Background layer of your image using *Layer > New > Layer from background*.

1 Select the Extract tool by choosing Extract from the Filter menu. Your image will open inside the Extract window.

2 Draw around the elements you wish to keep with the marker tool—in this case, the father and his son. Generally, the more accurately you can follow the outline, the better the final result, so zoom in on the image and take your time tracing around the outline.

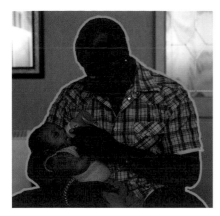

3 When you've completed the outline, select the Fill tool (the paint bucket icon) and fill the areas you wish to retain by clicking anywhere within the outline.

4 Click the Preview button to display the initial extraction. This isn't always perfect—in this example, parts of the father's shirt were missing, detail was lost from around his face, and some small sections of the background were still visible.

Finally, create a new layer below the newly extracted layer. This will be used for your new background. Click on the existing background layer and then use the Layer menu to add a new layer *(Layer > New > Layer)*. You can fill this layer with a color, as shown here, or with the new background image of your choice.

5 Use the Cleanup tool to improve the original extraction. Work your way around the image, painting over any problem areas. You can either remove further areas of the extracted image, or, by holding down the Alt(⌥) key, paint them back in again. Finally, you can use the Edge tool to smooth out and define the border. It's important to take your time with both these steps as the final image won't appear even remotely convincing if you rush this stage. When you're happy with the extraction, click OK and you will be returned to the main Photoshop window.

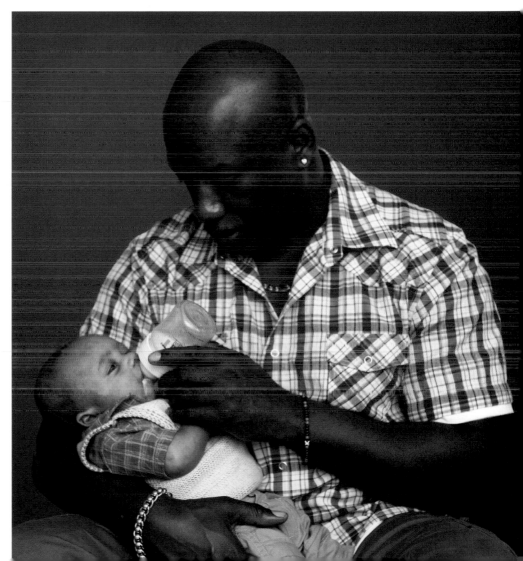

Favorite things montage

A montage is an effective way of showing a range of related objects, and can be much more compelling than a series of individual images. Montages are relatively easy to construct in Photoshop, but there are a few factors that you need to bear in mind.

The first, and most important, issue relates to the background. This must be seamless; the images must blend into one another unnoticeably, so the various components need to be photographed in a consistent style. For the three shots that comprise this montage I used a large sheet of white cardboard, bent into a curve, and lit the scene by combining window light, from a north-facing window, and flash, bounced from the ceiling. I could have overexposed each image, ensuring that each of the backgrounds was uniformly white, but I chose to correctly expose them knowing that I could use Photoshop to achieve this after they were taken.

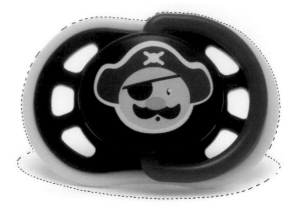

2 To do this, I first used the Magic Wand tool to select the background by clicking in the white area of the image.

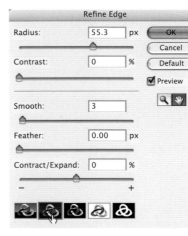

1 To check whether the background is completely white, examine the shot with the Eyedropper tool while the Info palette is open. In this case, you can see that the background isn't entirely white (the RGB values are 250, 249, and 249 respectively, whereas pure white is 255, 255, 255). So we need to lighten the background.

3 Next, I feathered the edge of the selection using the Refine Edge command, available from the Select menu. This is important; otherwise, any changes you make to the selected area would have a harsh edge and the change would look very unnatural. A radius of around 55px ensured that the transition between the two areas of the image wasn't too pronounced.

5 The original size of this image was 2820 × 2820 px, so I created a new image, 2820 pixels high and 8460 pixels wide (three times the width of the original.)

6 I copied and pasted the adjusted image into the newly created document and dragged it to the right of the document before adding the other two images, both of which were prepared in exactly the same way.

4 To lighten the selected area, I used an adjustment Curve *(Layer > New Adjustment Layer > Curves…)* and adjusted the top right point of the Curve to an input level of 248. When we examined the initial image we found that the luminance of the background was around 249 to 250. By setting a new white point of 248, we ensure that the majority of the background will be pure white.

The finished montage is a simple design on a plain white background.

The background has to be seamless, so all the components must be shot in a consistent style

Pop-Art montage

In this section, using a few simple steps in Photoshop, I will show you how to transform a photograph into a stylish piece of contemporary Pop Art.

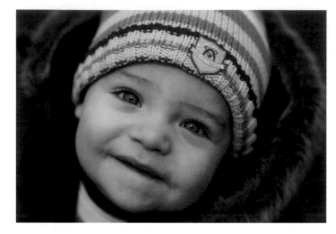

1 Open your image and duplicate the background layer by going to *Layer > Duplicate Layer*.

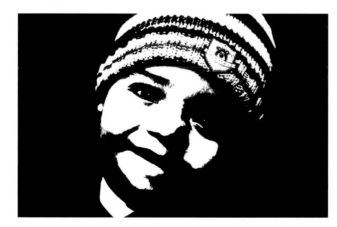

2 Use the *Image > Adjustments > Threshold* command (not the adjustment layer) to reduce the image to pure black and white. Drag the slider to between 1 (an almost pure white image), and 255 (a totally black image). The aim here is to convert the image into something recognizable, and in this instance the default setting of 128 retains a reasonable amount of detail in the child's face.

3 At this stage, we could proceed with colorizing the image, but it would be nice to get some detail back in the hood. To do this, duplicate the background layer again by dragging it onto the New Layer icon at the bottom of the Layers palette, then drag it to a postion above the newly created Threshold layer.

4 Now run the Threshold command again. This time I used a setting of 59 to bring out the detail in the hood.

5 Now click *Layer > Layer Mask > Reveal All* and switch to the Brush tool. With a hard-edged brush, paint over the face area in black. This will reveal the better detail in the original Threshold layer beneath.

6 Now for the coloring. First, create a new blank layer (*Layer > New > Layer*) and change its blend mode to Darker Color from the blend mode drop-down menu at the top of the Layers palette

8 To create the final combined image, start by clicking *File > New* and setting the new pixel width and height to be four times the size of the original—twice as wide and twice as tall. Return to your original document, select all the layers in the Layers palette (click on the top one and Shift-click on the bottom one), and the whole image area *(Select > All)*, then go to *Edit > Copy Merged*.

9 Switch back to the new document and select *Edit > Paste*, then drag the pasted image into one corner of the new document. Edit the colors of the original, perhaps with the Hue/Saturation's tool's Hue slider, then repeat the process to fill the page.

7 Use this layer to paint color back into the image. Select the color of your choice using the Color Picker and paint it in with the Brush tool (I recommend a large, hard-edged brush). After painting the face you can selectively color other areas of the image. This completes the first stage of your montage.

While the computer is a fantastic tool, you won't want to trap your sparkling fresh photography behind the monitor screen. This chapter looks at the many exciting new ways to transfer your work into print, hang it on walls, or display it on DVD, so it can end up where it was meant to be all along: in the memories of those who care about your child.

Output

There are a number of ways to share your photographs on the web, but perhaps the simplest is to generate a web gallery of your images. The methods discussed here work in similar ways to automate the process. Each takes a set of source images, resizes them, and then generates all the necessary code based on a presentation template that you choose. All you need to do, at the end of this process, is upload the files to your server.

USING PHOTOSHOP

To generate a web gallery in Photoshop, go to the File menu and select *Automate > Web Photo Gallery.* This will present you with a dialog where you can select various options. The Styles drop-down menu allows you to pick the theme for your gallery and a small preview of the final output appears on the right-hand side of the dialog. The next thing you need to do is specify the source and destination folders. Once you've done that, click OK and Photoshop will generate all the files you need for your gallery. If you've included a lot of images this can take quite some time, as Photoshop needs to open each image as it goes through this process.

When the process is complete, Photoshop opens the gallery in your default browser where you can preview the output.

Assuming you're happy with the final appearance of your gallery, you can now upload it to your server using your FTP (File Transfer Protocol) client. If you're using a Mac, Transmit (available from *www.panic.com*) is a good choice; if you are using a Windows-based system, you might want to try miFiles (*available from www.simdata.com.au/products/miFiles/miFiles.htm*).

> There are various automated methods for generating a web gallery of your images

USING iVIEW MEDIAPRO

An alternative to Photoshop, available for both the Mac and PC platforms, is iView MediaPro (available from *www.iview-multimedia. com/mediapro/*).

To begin using iView MediaPro, you first need to generate a library of images. Go to the File menu and select New. This will create an empty library into which you can drag and drop the images you want to use. Once your images are in your new library you can add

Photoshop can generate a range of simple yet stylish photo galleries automatically.

metadata, rate the images, and place them into the order you'd like them to appear in your gallery.

Next, go to *Make > HTML Gallery.* This will bring up a dialog that allows you to configure your gallery. You can add a title, choose from a variety of included themes, specify the layout of the Index Table (this is the thumbnail page for your new gallery), change the size of the thumbnails, and set the maximum size of

Once you've created an HTML gallery, you'll still need to upload it to the web by FTP.

iView MediaPro (or Expression Media)
is a cataloging utility which can display thumbnails of your photos, allow you to rate them with stars and perform batch actions.

One of the iView batch actions is to create a web gallery. Like Photoshop, it has a range of styles to choose from.

the images in your gallery. Once you're happy with the various settings, click the Make… button and iView MediaPro will generate all the necessary files.

Once the files have been generated, iView MediaPro will open your new gallery in your default web browser, and assuming that you're happy with the appearance of your gallery, you can now upload the files to your server.

To invoke iView's catalog tool, use the *Make > HTML Gallery* option from the main menu, then fill in the dialog.

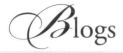
Blogs, weblogs, and photoblogs are user-generated websites which are often written in the style of a journal (for text-based blogs), with the entries published in reverse chronological order—either daily, weekly, or whenever the author feels inspired. They evolved from online diaries, and over recent years have become increasingly popular, both for personal and commercial use. For example, Xanga *(www. xanga.com)* hosted around 100 diaries in 1997, but by the end of 2005 this had risen to a total of over 20 million.

Unlike the web galleries we discussed in the previous section, blogs tend to be updated as and when the user has some new content to post. For example, one day you might add an entry of a few hundred words with a photograph; another day perhaps just a photograph or two. Over time, these individual entries may add up to form a gallery of related entries, but the emphasis is firmly upon adding new material incrementally.

A second difference between blogs and the galleries we discussed previously is that most blogs allow visitors to comment on the entries that are posted. For example, if you look at my blog *(www.chromasia.com/iblog/)*, you'll see that my visitors frequently comment on the images that I post—offering constructive critique and feedback, asking questions, and so on.

So why would you want to use a blog rather than a gallery? I use mine as a visual diary—a record of the work I'm doing at the time, photographs from projects that I'm working on, images of our children—and over the last three years or so I've added over 1000 images, all with accompanying text. In this sense, blogs are ideally suited to recording events as they unfold and would provide a good medium for chronicling your new arrival—shots taken before your baby was born, the birth, the early days of your child's life, and so on. And because most blogging solutions also allow comments, your friends and family will also be able to record their thoughts as the story unfolds.

Blogs are ideally suited to recording events—such as new arrivals—as they unfold

Generally speaking, there are two ways you can set up a blog: using a hosted solution, or using software that you install on your own server. The first is the easiest, insofar as you don't need to do much more than register an account and choose a name for your blog. Companies that offer free blogging accounts include Blogger *(www.blogger.com)*, Blogsome *(www.blogsome.com)* and Xanga *(www.xanga.com)*. All three of these allow you to customize your templates (to alter how your site will appear) and allow

A picture-led blog, with a large image forming the main page and text confined to a pop-up window.

A set of blog thumbnails from *www.chromasia.com/ibolg/thumbnails.php.*

The MovableType interface makes it easy to create a new blog entry.

you to post a combination of images and text). Another hosted solution, one more geared toward the posting of photographs than text, is PixyBlog *(www.pixyblog.com)*. This is a resource specifically designed for people who want to focus on blogging images and photographs rather than text.

The only problem with hosted solutions (other than PixyBlog) is that you are limited in terms of the extent to which you can modify the layout and structure of your blog. For a more flexible and powerful solution, you will need to consider one of the blogging solutions that you install on your own server. For these you download the files you need to run your blog, then upload them to your own server and configure them to your own requirements.

There are a variety of options to choose from, including Movable Type *(www.movabletype.org)*, WordPress *(www.wordpress.com)*, and Pixelpost *(www.pixelpost.org)*. Movable Type and WordPress are the most powerful and can be configured to your exact requirements. For example, one of the custom templates I use on my website produces a gallery of small thumbnails of all the images I've posted. Pixelpost, on the other hand, is considerably easier to install and administer but isn't as easy to customize.

What all these solutions share, whether hosted or installed on your own server, is that you administer and update them using a browser-based interface. For example, whenever I want to create a new entry I simply log into my Movable Type account and click the New Entry button. I then fill in the various fields

and then post the entry. At this point, Movable Type adds the entry to my database and rebuilds the relevant web pages for me.

Whichever solution you choose, blogs are an excellent way to share your photographs of your baby as and when they become available, and they're a great way to allow your friends and family to join in by leaving comments on the material you post.

If you're interested, or looking for inspiration, you might want to check out some other photoblogs. Good places to start are *photoblogs.org*, which currently lists over 22,000 photoblogs, and *coolphotoblogs.com*, which links to several thousand photoblog sites.

\mathcal{D}VD slideshows

The universal adoption of the computer-friendly DVD format is great news if you want to share your images. Almost all computers sold today include a DVD writer, which, with the correct software, can create discs that will play in a domestic DVD player. There are drawbacks—DVD resolution is very limited compared to that of a digital camera or computer monitor—but the ubiquitous presence of the players more than outweighs the problems.

DVD players will not, however, simply read your picture files from the disc like a computer can, since most do not recognize computer files. Instead you will need a program to take the digital camera information and convert it so that it fits the requirements of the DVD-Video specification. Every Mac includes iDVD, which is designed for just such a task, and some versions of Microsoft Windows Vista include Windows Movie Maker, which allows you to achieve a similar result.

1 Windows Movie Maker (or iMovie for Mac users) makes it possible to give your images a little more life. Whichever platform you are using, begin by importing your images.

2 You can choose to apply effects like Zoom (or the "Ken Burns effect" as Apple call it) so that the image slowly closes in on a certain point.

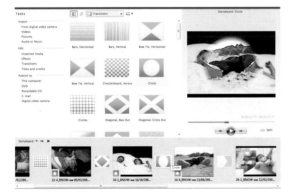

3 Another advantage of using a video-editing program (especially in comparison to the rather basic Windows DVD Maker) is the full range of transition wipes available to you.

4 When you've completed your video, hand over to the DVD-burning application (Windows DVD Maker or Apple's iDVD, for example) to create menu pages and burn your disc.

Whether you choose these options or prefer to use separate applications like Adobe's Encore DVD, or Apple's DVD Studio Pro, the principles of DVD are very much the same. The pictures can either be presented as part of a movie feature or as still pages. It is possible to set the player to switch images automatically or only in response to the viewer's remote control. Because the format is designed for moving images, cool transitions are also no problem.

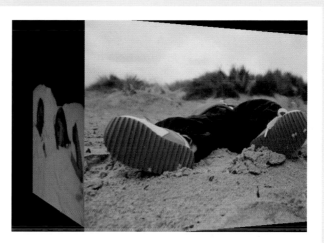

iDVD allows you to choose from several transitions, including the Cube, in which the old image appears to rotate away to be replaced by the new.

If you're creating your slideshow in a dedicated program like Apple's iDVD, you will find various options not available movie editing software. It is possible to adjust slide duration, transition effect, and music, and add remote skipping, to name just a few choices.

Modern inkjet printers, from manufacturers such as Canon, Epson, and others, allow you to produce archival quality prints on a range of photographic papers and other fine-art media. For example, the Epson Stylus Photo R2400 (pictured) uses eight separate colors to produce prints that are virtually indistinguishable from those you would receive from a professional lab. Such high-quality results can be consistently achieved from your desktop, but there are a couple of things to bear in mind.

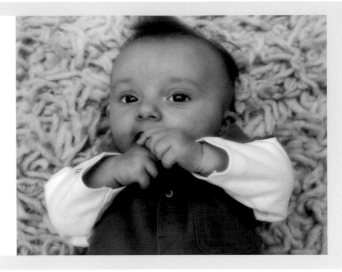

The first of these is color management. In essence this is how Photoshop ensures that what you see onscreen looks the same as the image you print. A color profile is a set of instructions that tells each device how the colors in an image should be represented, and the most important of these, with respect to printing your own images, is the color profile for your monitor. If your monitor is badly calibrated or calibrated using an incorrect profile, then the image you view won't be a true representation of the data within that image and your prints will not match the ones you see onscreen. Fortunately, it is a fairly simple process to calibrate your monitor and ensure that your prints are consistent with your display.

> If your monitor is badly calibrated, your prints won't match the screen

HARDWARE CALIBRATION

The first and best alternative is to use a hardware device that you attach to your screen. Two popular models are the Eye One devices from Gretagmacbeth (*www.gretagmacbeth.com*) and the Spyder2 from ColorVision (*www.colorvision.com*). Both of these work in the same way and use their supplied software to analyze your screen. Once they have completed their anlaysis they generate a color profile that you can use to ensure that your display reflects the true colors of the document you're working on.

SOFTWARE CALIBRATION

While hardware calibrators are not especially expensive, there are various software solutions that can achieve similar results, though they are by no means as accurate. One solution, built into OS X for Apple computers, is the Display Calibrator Assistant. To launch the assistant, go to the Displays preference pane, click the Color tab, then the Calibrate button on the right of the screen. Similar tools are available for Windows, depending on the graphics card

A software calibration procedure from Mac OS X. This asks you a series of questions which it uses to create a color profile for your display.

manufacturer you have chosen. There is also an Adobe Gamma tool included with (but no longer necessarily installed automatically with) Photoshop and Photoshop Elements. These are considerably less reliable in the age of digital flat panels, but are still useful, especially on cathode ray (CRT) screens.

PRINTING

To get the most from your printer there are a few stages you need to go through within Photoshop to ensure that your prints accurately reflect your onscreen images.

First, use the *File > Page Setup* dialog to specify the printer you are going to be using, the paper size, and the orientation. It's always worth checking that these settings are correct.

Secondly, when the setup options are correct, select *File > Print* and you will be presented with Photoshop's comprehensive Print dialog. Immediately to the right of your previewed image you can see the Scaled Print Size options. Use these to set the final size of your image. In the example below I used 9 × 6 inches (23 × 15 cm). To the right you will see a set of options that relate to the color management of the file to be printed. The settings you use should reflect the ones you can see here, but it is important to change the Printer Profile to reflect the type of paper you're printing onto.

When you click Print, Photoshop hands over its information to the printer's own software (which you encounter no matter which program you are printing from). Although the appearance of the windows varies, the principle is the same. There are two more things you need to set: the paper type and the quality of the final print. In this example I used the Advanced Settings radio button to enable me to set the best quality possible.

Before you leave this dialog you must also set the Color Management option to No Color Adjustment (assuming you chose

For best results, always specify the kind of paper you are using as well as the Detail setting. You should always choose the highest available detail setting for the kind of paper you are using.

to let Photoshop manage the colors). If you enable the Color Controls or ColorSync within this dialog, this will interfere with the previous setting and the results you get will be unpredictable.

Finally, all you need to do is click the Print button and wait for your printer to produce an image that should be a very good match to the image on your screen.

One of the most popular ways of displaying your photographs is to have them printed onto canvas, either as single photographs, sets of related images, or a single picture divided into a number of sections (a good example of a set of photographs that would work well as group of canvasses would be the images I used to construct the Favorite Things montage on page 102). Whether you use a single photograph or a set, this process instantly transforms a photograph into a piece of art, and is very easy to achieve, not least because once the image is prepared, you hand it over to someone else, and wait for the finished product to be delivered to your door.

There are many companies that offer this service, catering for most budgets, but there are a few things to think about before you select the provider you will use.

Firstly, you will want to know about the canvas. One hundred per cent cotton artist's canvas is often recommended, because the inks do not just sit on the canvas but soak in, so that your picture will not crack when stretched.

Then you will want to know that the image will not fade, so check that your chosen company is using archival-quality inks, which should last for around 75 years. Many firms also protect your image by applying a giclée varnish.

Finally, check that all the fixings (usually staples) are on the rear of the frame, and that the edges of the frame are chamfered. This ensures that the edge of the frame won't damage the canvas over time.

All companies should offer advice on image resolution and print size, but as a rule the largest size your image can be printed (in inches) can be determined by dividing the height and width of your image in pixels by 100. For example, if your image is 1024 pixels by 768 pixels, then the maximum recommended size it can be printed at is 10.24 × 7.68 inches (26 × 19 cm). Any size below this will avoid pixelation on the canvas print.

Some companies also offer additional services, such as converting to sepia or black and white, creating Pop Art effects or adding text. Others offer a free retouching service or will automatically optimize your image, so if you don't want your image altered, it is worth saying so when you place your order. Other companies will send you a preview image before they print, so you can check exactly what you are getting.

This process can instantly transform a photograph into a unique artwork

Once you've chosen your supplier, you need to select the image and decide on the size. This is usually only restricted by your budget and the planned location of the finished photograph. There is considerable scope here, as most suppliers can produce a wide range of sizes—from 8 inches square to 8 feet—which should cover most domestic needs! However, as mentioned previously, the size and resolution of your original image will affect the quality of your print, so bear this in mind.

You then usually have a choice of how the canvas is stretched and framed. A traditional canvas wrap is produced with your photograph on the front, leaving the sides unprinted. Having your photograph produced as a gallery wrap involves wrapping the image around the edge of the frame. Other alternatives include using black or some other color for the edges of your canvas, or edging your canvas with wood.

If you decide on the gallery style, take a few moments to work out how your photo will look with the edge of the image wrapped around the sides. For example, the image of my daughter with her younger brother would make a great canvas wrap, but only if it was printed at quite a large size. In the 12-inch example below, too much of the detail ends up being wrapped around the edges, but printed at 60 inches, even with a two-inch frame, it looks much better.

Once you've made all these decisions you can submit your photograph to the printers and then just sit back and wait for the finished version to arrive.

12 × 12 inches (30 × 30 cm) with 1-inch (2.5 cm) frame.

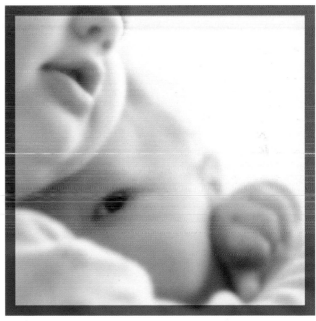

60 × 60 inches (1.5 × 1.5 meters) with 2-inch (5 cm) frame.

Designing an album

When constructing an album, you may be tempted to simply present your photographs in chronological sequence, adding new ones as and when they become available—and if the album is solely for your own viewing, then this is fine. You will remember when and where they were taken, and any other small details that will turn your album into something more than just a catalog of shots.

For other viewers, though, the story might not be quite so apparent, and their experience of your album will not be as rich as yours. Under these circumstances it's worth spending some time designing an album. This will ensure that the viewer can follow the story that ties the various shots together. You can also add captions: the date they were taken, what was on your mind at the time, and so on. These will help to tell the story that you want to get across.

It's also worth bearing in mind that different audiences will appreciate some photographs more than others. For example, friends and acquaintances would probably appreciate a more condensed version of the story than close family members.

In this sense then, there are two things you need to consider when designing and constructing an album: the story that you want to tell, and the audience who will view it.

One of the first albums you could produce, even before your child is born, is one that chronicles the preparations you made prior to their birth: decorating the nursery, the toys and clothes you bought for them, photographs of yourself and your partner, and so on. Clearly this isn't going to be something they appreciate immediately, but it would give them an insight into your lives, in the weeks and months before their arrival.

Consider the story you want to tell, and who will be viewing it

Using a program like Adobe Photoshop Elements or Apple iPhoto, which is backed up with an online printing service, it's extremely easy to construct photographic albums—from a few pages to several dozen—including your photographs, an overall theme, and some accompanying text. For this example, you could add a photograph to the front cover to represent one of the important moments before the birth. Within the album you can include single or multiple photographs on a page detailing the preparations that you made for their arrival, and you could finish the album with a shot taken some time during their first few days.

1 If you're using iPhoto, choose Book from the buttons beneath the main viewing area, then choose a size and style.

2 Edit the pre-defined text areas on the title page, then click on the Next Page button at the bottom right.

1 If you have Photoshop Elements, open the program and select the Make Photo Creations option. Pick a page layout in the resulting dialog.

2 Give that layout a touch of style using one of the many options available. This is the Old Paper look. Click OK when you have made your selection.

3 You will be presented with a blank page. Drag your choice of photo from the scroll bar at the top onto the desired of area of the page.

The printed cover design

3 A special Photoshop Elements file appears into which you can drag other image files. Create as many pages as you like and print out your completed album.

Gift mementos

A decade ago, grandparents delighted in being presented with an baby album at Christmas: choice photos were displayed in small frames on side tables, while the remaining baby photos were kept in boxes or albums, rarely to be seen. Thankfully, largely due to the advances in technology and manufacturing, things have changed, and you can now have your photographs printed onto items as small as key fobs and fridge magnets, or, at the other extreme, transferred onto rolls of wallpaper, sufficient to cover an entire wall.

On the previous pages we discussed photo books—a modern version of the photo album. The smallest photo book from iPhoto is 3.5×2.6 inches (9×6.6 cm), is relatively cheap for a 20-page book, and would make an ideal gift for friends and relatives. Other obvious items include mugs, mouse mats, and calendars, and the majority of these are available from most photo printers.

However, a quick Google search will show that the scope for photo gifts and mementos is almost endless, with prices to suit every pocket.

Some of my favourites can been found at *www.mybiggerpicture. com* and *www.bagsoflove.co.uk*. Here, and at many similar sites, you will find a huge range of professionally produced gifts using your photos. You can still buy a mouse mat or mug, but you can also find far more creative ways of displaying you photographs.

The scope for personlized gifts is almost endless, with prices to suit every pocket

What about a deckchair for grandpa or an oven glove and apron for grandma, all featuring their latest grandchild? Or treat yourself to a tote bag to use as a trendy and personalized alternative to a diaper bag.

Other options include wash bags, cushions, glasses cases, cosmetic bags, holdalls, tins and boxes, jigsaws, address books, and even a DAB radio, personalized with your photograph.

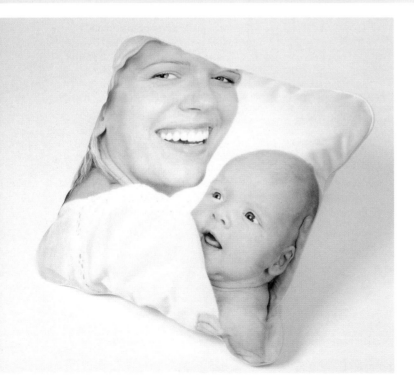

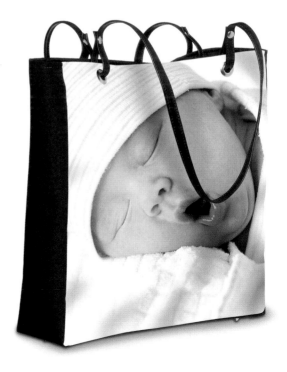

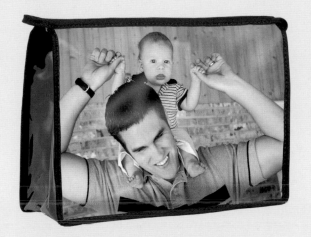

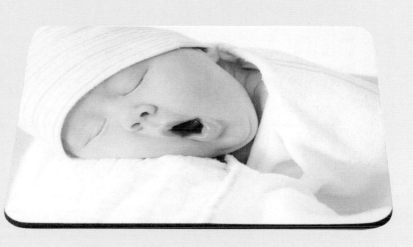

If you want to make a really BIG statement you could have your photo turned into a roller blind, wallpaper, or a folding screen.

Best of all though, the process couldn't be easier. First of all, find your chosen product and add it to your basket. When you have finished shopping, you need to pay for your item, after which you will then able to upload your image as a TIFF or JPEG.

Bear in mind the format required for the item you have chosen—landscape, portrait, or square—and how your photo will appear when cropped. This is important because your item will be made to order, so will not usually be exchanged just because you don't like it. However, most companies will be happy to advise you, and some will email you a proof before printing your order. Many also offer basic services such as converting color to black and white or sepia, redeye correction, blemish removal, and so on.

If you own a digital camera, you should never again be stuck for gift ideas. Online services offer a huge range of items that can be personalized with your own images.

Top ten tips

1 TAKE LOTS OF PHOTOGRAPHS

On my website I have a blog section where I post an image a day (www.chromasia.com/iblog), and one of the questions I'm frequently asked is "How do you manage to produce such consistently good images?" What my visitors don't see, though, are all the images I reject. On a good day, I would expect that around one in 20 of the photographs I take will be worth posting on my web site. On a bad day I can take hundreds of images and not like any of them.

Another reason for taking lots of photographs is that babies and children who are not used to being photographed will either be self-conscious, or will "perform" for the camera. If your baby becomes used to you taking a lot of shots you will find that they look much more natural as a result.

2 USE YOUR HISTOGRAM

Get used to checking your histogram after you have taken a shot. Virtually all digital cameras have a histogram that allows you to preview your exposure and check that you didn't underexpose or overexpose your photograph. Mild underexposure can be corrected when you post-process your images, but overexposed images often can't be saved as the over-exposed areas are recorded as pure white—there is no detail that can be recovered.

3 BUY GOOD LENSES

When buying a DSLR try to budget for a good lens. The kit lens, supplied with new DSLRs, will take tolerably good photographs, but these are very much budget lenses. If you can't afford one of the more expensive zoom lenses that are available, you might want to consider a fixed focal length lens instead. Canon and Nikon's 50mm standard lenses are both bargains and both have a wider maximum aperture than the kit lenses, and both will produce noticeably sharper photographs.

4 BE PATIENT

When photographing babies and small children, it pays to be patient, not least because they cease to notice your presence after you have been photographing them for a while. It's also worth noting that it's almost impossible to pose babies and children, at least not convincingly, so if you take your time you stand a much better chance of getting a good photograph.

5 PLAN YOUR SHOTS

Where possible, plan your shots. Think about the equipment you will need, the aperture you will use, what needs to be removed from the background, and so on. As you become more experienced, some of these things will become second nature, but in the first instance, the more time you spend thinking about how to take a particular photograph, the better it is likely to be.

6 THINK ABOUT THE LIGHTING

It's easy to forget about lighting—it's taken for granted in every scene you photograph—but try to spend some time evaluating the light before taking each photograph. For example, if you are planning some indoor portraits and want to use available light, think about which room would be the best location and at what time of day you will take the shots. You also need to think about whether you will use flash, and if so, how will you diffuse it.

7 PROFILE YOUR MONITOR

If you wish to produce prints of your photographs it's essential that you profile your monitor so that it will accurately display the colors in your photographs. This process was described on pages 114-115, but I've mentioned it again here, as a poorly calibrated monitor will make producing high-quality prints of your photographs almost impossible.

8 TRY ALTERNATIVE FORMS OF PROCESSING

Often, when I'm post-processing an image, I will try out different techniques until I find one that I'm happy with. For example, I may be working on a very colorful image but just can't get it to look the way I want. At this point I would probably try converting it to black and white, or toning it, or applying some other technique until I found an approach that worked with that image.

9 FILE YOUR IMAGES

Over time, you will take many thousands of images, and it can become increasingly difficult to find a particular image unless you develop some sort of system for arranging them on your computer.

10 BACK UP YOUR IMAGES

A few years ago I bought a new computer and transferred all my images from the old machine to the new one. At least I thought I had, and didn't realize that I'd missed several hundred of them until long after I'd deleted them from my old machine. These days, I'm much more careful and have multiple copies of all my images, stored on a server and an external firewire drive. If neither of those options are available you can also back up your images onto CDs or DVDs. The important thing is that you have more than one copy.

\mathscr{K}eyboard shortcuts

LAYER	Mac	PC
New Layer	⌘+⇧+N	Ctrl+Shift+N
Layer via Copy	⌘+J	Cmd+J
Layer via Cut	⇧+⌘+J	Shift+Cmd+J

SELECT	Mac	PC
All	⌘+A	Ctrl+A
Deselect	⌘+D	Ctrl+D
Reselect	⇧+⌘+D	Ctrl+Shift+D
Inverse	⇧+⌘+I	Ctrl+Shift+I
All Layers	⌥+⌘+A	Ctrl+Alt+A
Refine Edge...	⌥+⌘+R	Ctrl+Alt+R
Feather...	⌥+⌘+D	Ctrl+Alt+D

ZOOM	Mac	PC
Zoom In	⌘+⊞	Ctrl+⊞
Zoom Out	⌘+⊟	Ctrl+⊟
Fit on Screen	⌘+0	Ctrl+0
Actual Pixels	⌥+⌘+0	Alt+Ctrl+0

WINDOW	Mac	PC
Actions	⌥+F9	Alt+F9
Brushes	F5	F5
Color	F6	F6
Info	F8	F8
Layers	F7	F7

TOOLS	Mac or PC
Move Tool	V
Rectangular Marquee Tool	M
Elliptical Marquee Tool	M
Lasso Tool	L
Polygonal Lasso Tool	L
Magnetic Lasso Tool	L
Quick Selection Tool	W
Magic Wand Tool	W
Crop Tool	C
Slice Tool	K
Slice Select Tool	K
Spot Healing Brush Tool	J
Healing Brush Tool	J
Patch Tool	J

Red Eye Tool	J
Brush Tool	B
Pencil Tool	B
Color Replacement Tool	B
Clone Stamp Tool	S
Pattern Stamp Tool	S
History Brush Tool	Y
Art History Brush Tool	Y
Eraser Tool	E
Background Eraser Tool	E
Magic Eraser Tool	E
Gradient Tool	G
Paint Bucket Tool	G
Blur Tool	R
Sharpen Tool	R
Smudge Tool	R
Dodge Tool	O
Burn Tool	O
Sponge Tool	O
Pen Tool	P
Freeform Pen Tool	P
Type Tools	T
Path Selection Tool	A
Direct Selection Tool	A
Shape Tools	U
Notes Tool	N
Audio Annotation Tool	N
Eyedropper Tool	I
Color Sampler Tool	I
Ruler Tool	I
Hand Tool	H
Zoom Tool	Z
Default Foreground/Background Colors	D
Switch Foreground/Background Colors	X
Toggle Standard/Quick Mask Modes	Q
Toggle Screen Modes	F
Toggle Preserve Transparency	/
Decrease Brush Size	[
Increase Brush Size]
Decrease Brush Hardness	{
Increase Brush Hardness	}
Previous Brush	,
Next Brush	.
First Brush	<
Last Brush	>

Index

A
adjustment layers 77, 86, 88–89, 91–94, 96, 99, 103–4
Adobe 14, 78, 80, 113, 115, 118, 120
Advanced Settings 115
albums 118–20, 122
Amazon 120
aperture 11–13, 24, 49, 58, 69, 90
Apple 112–14, 118
archiving 114, 116
artificial lighting 70, 72
autofocus 10

B
background 16, 49, 54, 86, 97–98, 100–102, 104
backlighting 10, 17
backup 15
Bagsoflove 122
bathing 46
birthday cakes 20, 38
Black & White 36, 77, 86, 92–94, 99, 116, 123
blending modes 105
Blogger 110
Blogsome 110
Blu-Ray 15
blur 13, 49, 54, 80, 90–91
Blurb 120–21
book publishing 120–21
Bridge browser 78, 80
Brush tool 104–5

C
Cafepress 120
calibration 15, 78, 114–15
Camera Raw 78
cameras 10–11, 17
Canon 10, 12, 16, 40, 90, 114
canvas prints 116–17
capture mode 11
Capture One 80
CDs 15
Christmas 20, 122
Chromasia 110
Cleanup tool 101
Clone tool 84–85
close-ups 58
color channels 88, 94
Color Management 115
Color Picker 105
color profile 114
color temperature 11, 72
color wheel 92

Colorize 94
ColorVision 114
composition 38, 69, 76, 80
compression 78
computers 14–15, 80, 112, 114, 120
contrast 78, 96
conversion 78, 86, 92, 123
Cooling filter 89
Coolphotoblogs 111
Copy Merged 105
Crop tool 76
crying 68–69
Curves tool 70, 77, 81, 84, 86–89, 91, 94, 96–97, 103

D
Delete key 98
depth of field 13, 24, 58, 69, 90
Desaturate command 92
detail 58, 92, 104, 117–18
diffusers 16, 18–19, 40, 70
Digital Rebel 12
Display Calibration Assistant 114
Distiller 120
Duplicate Layer 90, 104
DVD Maker 112
DVD Studio Pro 113

E
Edge tool 101
Elements 115, 118–19
Encore DVD 113
Epson 114
Eraser tool 87
exposure compensation 17, 60
Extract 100
Eye One 114
Eyedropper tool 84, 88, 102
eyes 13, 27, 62, 68, 80, 82, 87

F
Feather 99
feeding 36, 38
file formats 11, 78, 120
File menu 108
file size 11, 15
File Transfer Protocol (FTP) 108
fill flash 17, 60, 70
Fill Light slider 78
Fill tool 101
Filter menu 100

Firewire 15
fixed focal 12, 49
flash 11, 16–19, 35, 40, 46, 51, 60, 70, 82, 102
focal length 12–13, 54, 69
focal point 49, 58, 62, 69
Forestier, Bruce 23

G
Gamma tool 115
Gaussian Blur 91
gifts 38, 122–23
Google 122
graphics card 114–15
graphics tablet 15
grayscale 78, 92
Gretagmacbeth 114
Guide Number 16

H
hard drive 15
high key 70
highlights 70, 95
histograms 10
History palette 77
hotshoe 11
HTML Gallery 108
Hue/Saturation tool 77, 91–92, 94–96, 105

I
iDVD 112
Image menu 77
Image Stabilization (IS) 13
iMovie 112
Index Table 108
inket printers 114
inks 116
intimacy 60, 62
iPhoto 118, 121–22
ISBN 120
iView 108–9

J
JPEGs 11, 14, 28, 78, 123

K
Kodak 10

L
landscapes 12, 49
Layers palette 77, 86–87, 89, 91, 99, 101, 105

Acknowledgments

This book would not have been possible without the help of many people, including our wonderful models and their parents. So I would like to offer our sincere thanks to Chia, Evan, Ezra, Shannice, Tonisha, Harrison, Fendi, Carly, Jack, Alfie, Max, Ryan, Phoenix, Akeelah, Harry, and their families. I would also like to thank Jacquie Morley at the Blackpool Gazette for helping us recruit all these wonderful babies and to Emma for allowing me to photograph her pregnancy.

I also owe a big thank you to my children, Amirah, Camilla, Rhowan, Harmony and Finley; who have not only featured in this book, but have been infinitely patient while I have been busy with this project.

Last but not least, I would like to thank Libby, my wife; for proofreading each chapter, offering critiques of the various photographs I took for the project, and arranging the shoots. It wouldn't have been possible without her.

USEFUL WEB LINKS

My tutorial pages – www.chromasia.com/tutorials/ - this site contains information about our own weekend and online tutorials.

Luminous landscapes - http://www.luminous-landscape.com/ This site includes a range of useful material including tutorials, product reviews, essays and articles, and so on.

Photoshop TV - http://www.photoshoptv.com/ This site offers a number of online video tutorials

Digital Photography Review - http://www.dpreview.com/ The latest news and reviews of new equipment.

Fredmiranda.com - http://www.fredmiranda.com/ User reviews of all the latest equipment and various other photography related articles.

Gomma portal - http://www.gommamag.com/v3/index.html A portal to various resources including exhibitions, online galleries and their own magazine.

Photoblogs.org - http://www.photoblogs.org/ Contains links to over 22,000 photography blogs, organised by tags and location.